Vasily

Kandinsky

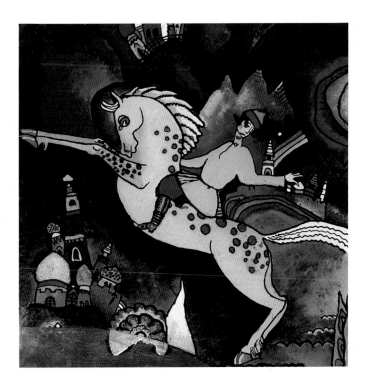

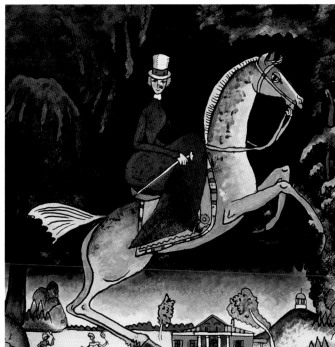

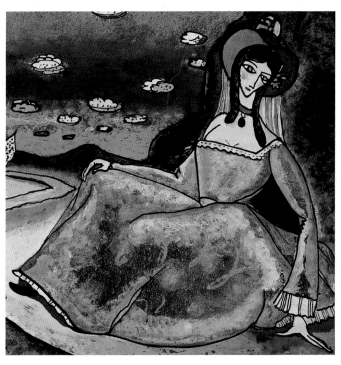

© 2005 Sirrocco, London, UK (English version)

© 2005 Confidential Concepts, worldwide, USA

© 2005 Estate Kandinsky / Artists Rights Society, New York, USA /
ADAGP, Paris

ISBN 1-84013-762-2

Published in 2005 by Grange Books
an imprint of Grange Book Plc
The Grange Kingsnorth Industrial Estate
Hoo, nr Rochester, Kent ME3 9ND
www.Grangebooks.co.uk

Printed in China

Vasily
Kandinsky

Grange
BOOKS

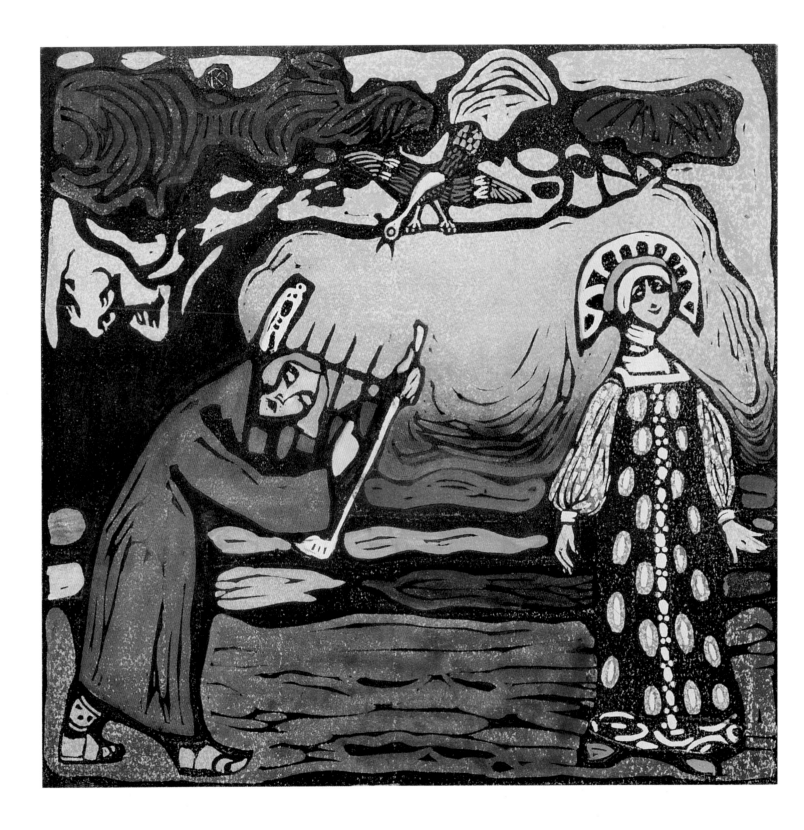

Not long ago it seemed that this century had not only begun with Kandinsky, but had ended with him as well. However, no matter how often his name is cited by the zealots of new and fashionable interpretations, the artist has passed into history and perhaps belongs to the past and to the future to a greater degree than to the present.

Moreover, Kandinsky's art does not reflect (or, if one may say so, is not burdened by) the fate of other Russian avant garde masters. He left Russia well before the semi-official Soviet esthetic turned its back on modernist art. He himself chose where he would live and how he would work. He was forced neither to struggle with fate nor to enter into conspiracy with it. His "struggles" took place "with himself" (Boris Pasternak). The persecutions to which "leftist" artists in Russia were subjected left him untouched and did not complicate his life. Neither, however was he was awarded a crown of thorns or the glory of a martyr, like the lot of those famous avant-garde artists who remained in Russia. His reputation is in no way obliged to fate — only to art itself.

The culture of the past was for him precious and intelligible: he was not concerned with the smashing of idols. Creating the new occupied him fully. He aspired neither to iconoclasm nor to scandalous behavior. It could hardly be said that his work lacked daring, but it was a daring saturated with thought, a polite daring that argued with art of the highest quality.

Educated in the European manner, a man of letters, a professional musician, and an artist much more inclined to reflection and to strict (but not altogether unromantic) logic than to loud declarations, Kandinsky preserved the dignity of a thinker, refusing to dissipate this dignity in petty quarrels within the artistic world. It has been said many times and said justly that the roots not only of Kandinsky's art, but of his attitude to life in general, lay in Russia and Germany.

In intellectual terms, especially as concerns philosophy, Kandinsky was oriented towards the German traditions. But notwithstanding his interest in the past, he did not become its hostage, seeing in its wisdom the foundations for understanding and building the future. Kandinsky painted his earliest works when already a mature man.

Kandinsky was in the zenith of his fourth decade, a time in life when it is not easy to feel oneself a beginner. His first known canvasses date from the turn of the century: 1899 — *Mountain Lake* (M. G. Manukhina collection, Moscow) (p.6); 1901 — *Munich. Schwabing* (Tretyakov Gallery) (p.7), *Akhtyrka. Autumn* (Städtische Galerie im Lenbachhaus, Munich) (p.8); c. 1902 — *Kochel* (Tretyakov Gallery) (p.9). The painting *Odessa — Port* (late 1890s, Tretyakov Gallery) (p.28), which opened the celebrated 1989 Kandinsky retrospective, already contained a certain magic.

1. *Gouspiar*, Tretyakov Gallery, Moscow.

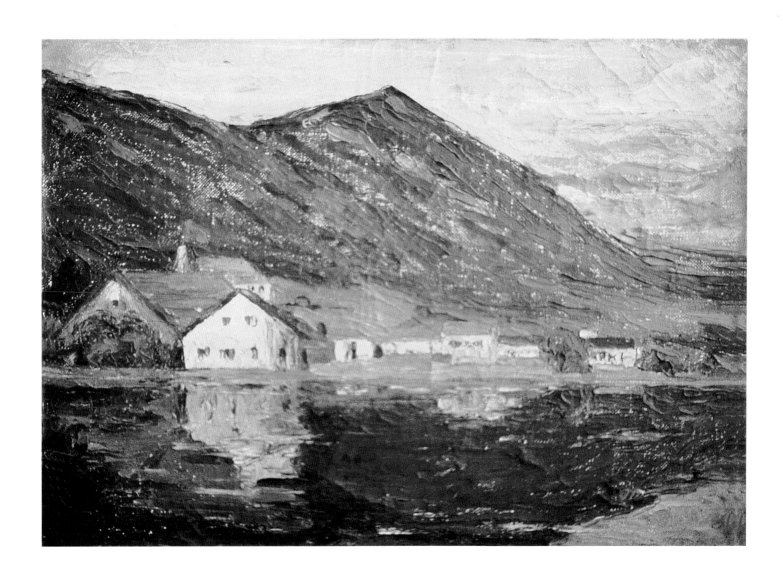

2. *Mountain Lake*, 1899,
Oil on canvas,
50 x 70 cm, Manukhina
Collection, Moscow.

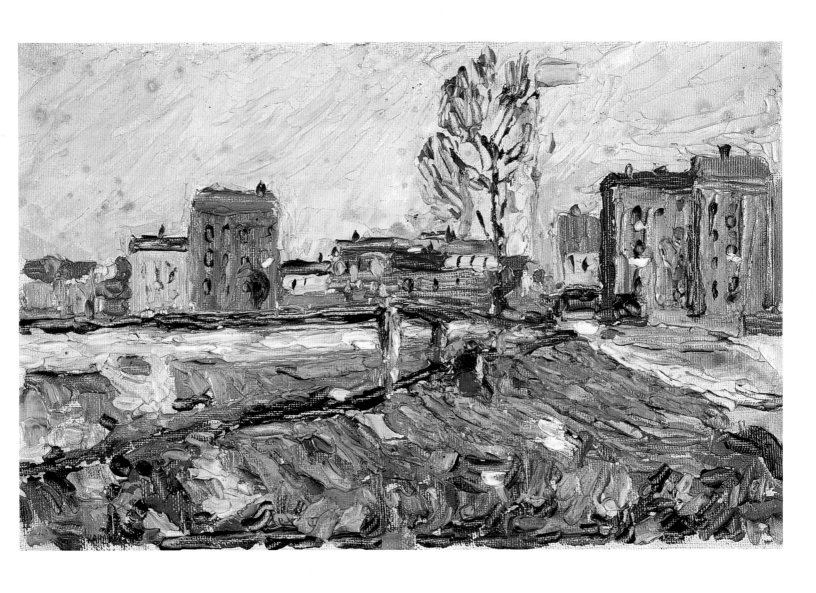

3. *Munich, Schwabing,*
 1901, Oil on cardboard,
 17 x 26.3 cm, Tretyakov
 Gallery, Moscow.

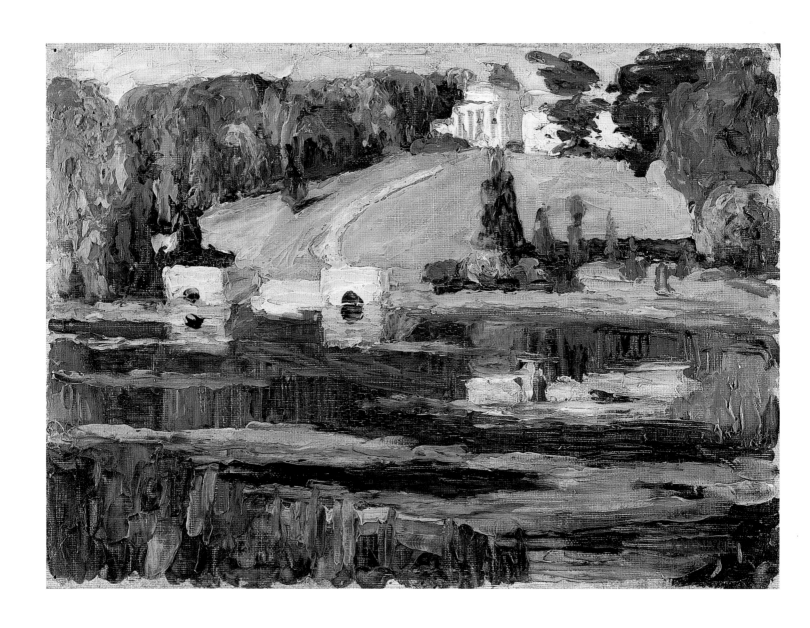

4. *Achtyrka, Autumn*,
 sketch 1901,
 Oil on canvas,
 23.6 x 32.7 cm,
 Städtische Galerie im
 Lenbachhaus, Munich.

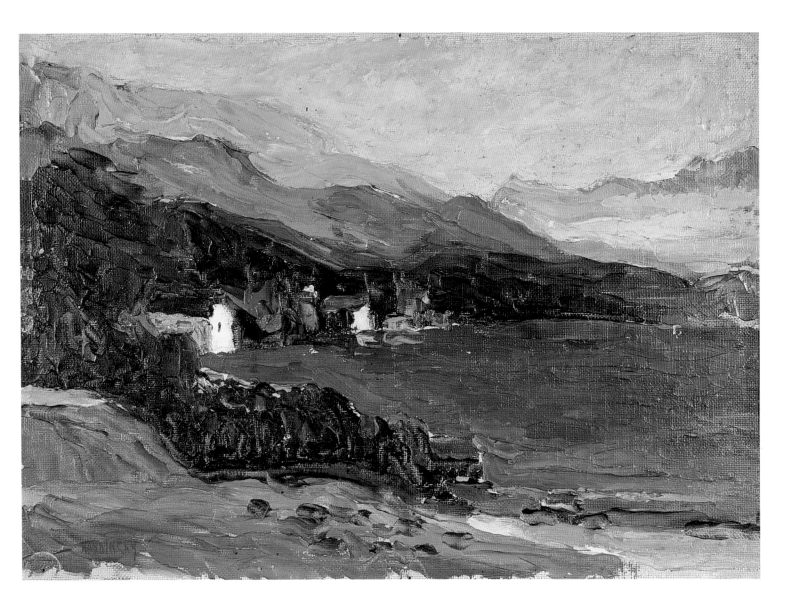

5. *Kochel (the Lake and the Hotel Grauer Bär)*, c. 1902, Oil on cardboard, 23.8 x 32.9 cm, Tretyakov Gallery, Moscow.

While that exhibition was still being prepared, amidst the abstract works or alongside the pictorial insights of Murnau, this painting seemed nearly dilettantish and almost Wanderesque. But next to it, any Wanderer landscape seemed passive and rooted in an impression taken from life. Of course, looking for the traits of future genius in the work of a neophyte is a very sly pursuit: it is easy to find what one wants to find instead of what is there.

Nevertheless, its elastically outlined, dark and radiant patches are much too independent of the object world; there is too much hidden tension in them which is unconnected with any real motif. The much too powerful drawing appears purely decorative alongside a fairly naive and traditional understanding of objective form. There is no doubt that this strict and powerful intellect had an emotional existence as well. For a beginning student, Kandinsky was much too mature.

Generally speaking, he had already gained a lot of knowledge as a result of his extensive reading and thinking. He had been to Paris and Italy, even giving Impressionism its due in his earliest works (as we have already mentioned). However, it was only in Germany that he aspired to study. It is obvious that in his preference for Munich over Paris, Kandinsky had been thinking more about schools than about artistic milieus. In any case, when Kandinsky had only just enrolled in the private school of Anton Azbè, renowned for its unswerving professionalism, Igor Grabar wrote (apparently, with good reason) that Kandinsky "ha[d] no ability whatsoever" and that "he ha[d] a very foggy notion of decadence."

It may seem paradoxical, but, given his enormous talent and serious education, Kandinsky's "inability" and, moreover, his not being a decadent, allowed him to be independent of fashionable trends of the prevalent tradition. In other words, he was able to preserve the highest degree of artistic freedom. The study of drawing at the Azbè School did not bring Kandinsky much. He never developed a taste for academic studies, the nuts and bolts of the trade which attract so many artists.

But, as if following the well-known Chinese dictum, "Once you have understood the rules, you will succeed in changing them," he tried to learn the rudiments before setting about to "realiz[e] [his] own feelings" (Cézanne). It is hard for us to understand what attracted Kandinsky to Franz Stuck after Azbè. Perhaps it was the fact that Stuck taught at the Academy of Arts and not in a private school, that he was revered as the best draughtsman in Germany, or that he was more famous than other artists. Whatever the case, his work could hardly have served Kandinsky as a standard of good taste and deep originality. We are forced to suppose that it was merely Stuck's teaching method that interested Kandinsky.

6. *Poster for the first "Phalanx" Art School exhibition*, 1901, Color lithograph (after Kandinsky's drawing), 47.3 x 60.3 cm, Städtische Galerie im Lenbachhaus, Munich.

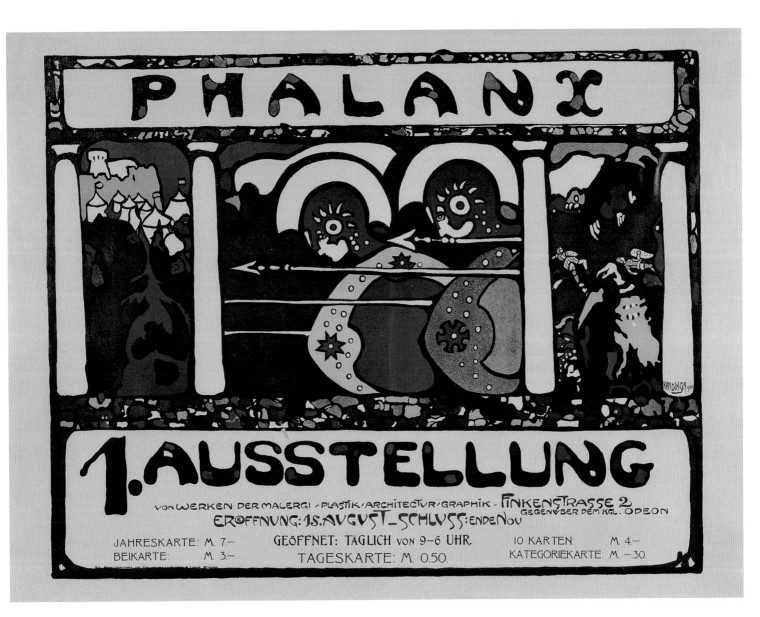

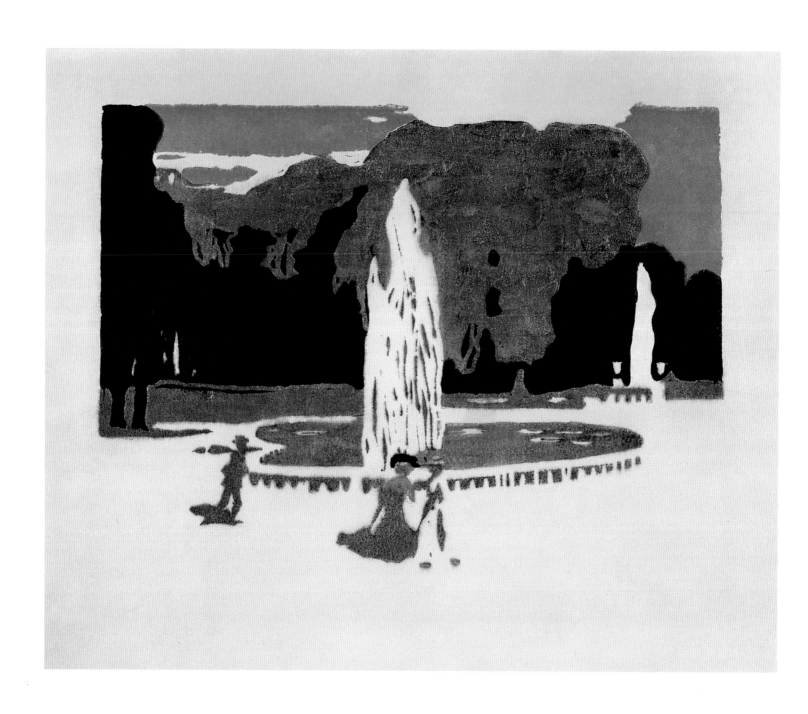

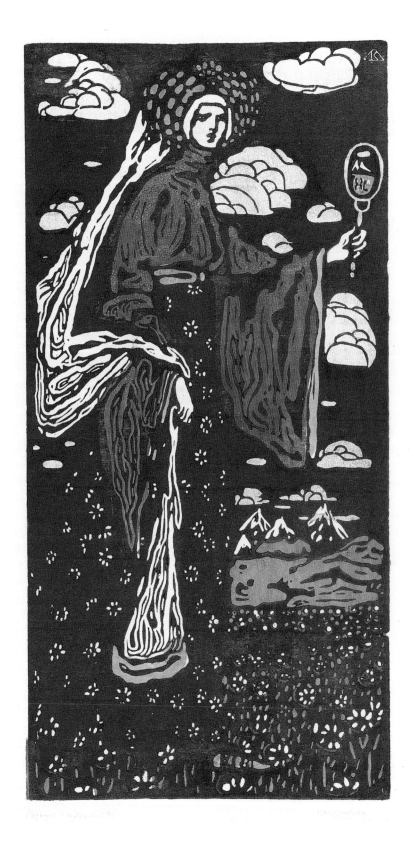

7. *The Parc of Saint-Cloud*,
 1904, Color xylograph,
 18.9 x 23.9 cm, Private
 Collection, Moscow.

8. *The Mirror*, 1907,
 Linoleum cut printed
 on japanese paper,
 Städtische Galerie im
 Lenbachhaus, Munich.

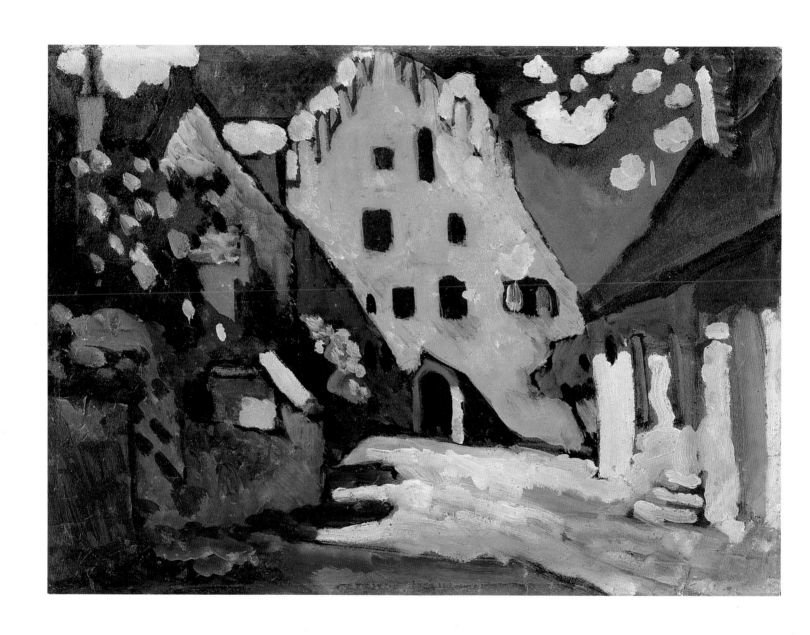

9. *Street in Murnau*, 1908,
 Oil on cardboard,
 33 x 44.3 cm,
 Tretyakov Gallery,
 Moscow.

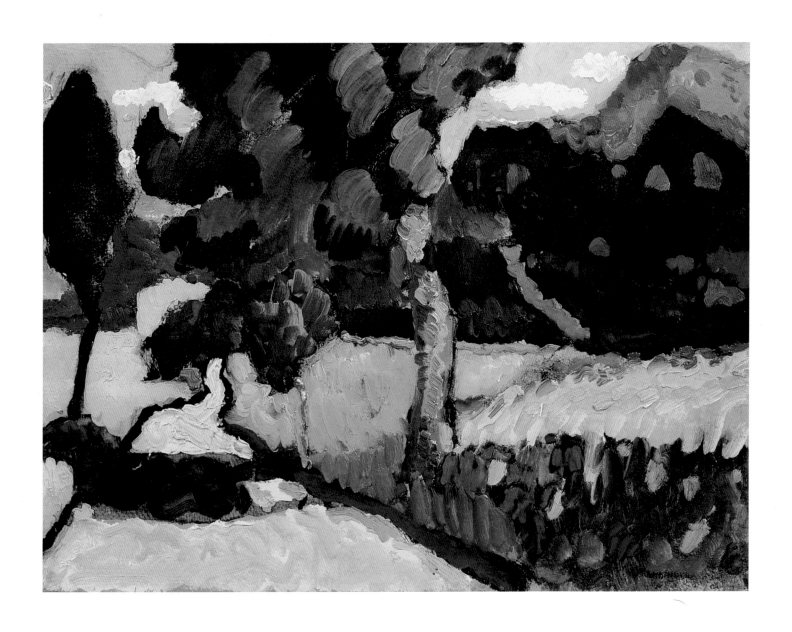

10. *Summer Landscape*,
 1909,
 Oil on cardboard,
 34 x 45 cm,
 Russian Museum,
 St. Petersburg.

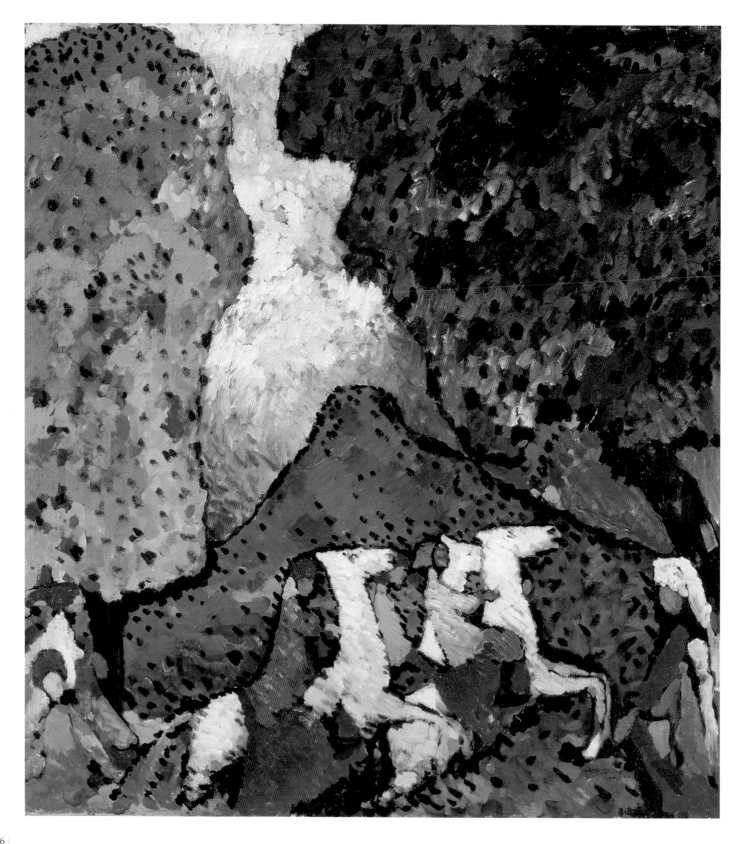

The gloomy and pretentious pathos of Stuck's works, the total absence in them of "the substance of art" (Merezhkovsky), his traditionally illusory depiction of pompous, "terrifying" heroes — all this was more likely to interest lovers of salon painting. Although Kandinsky succeeded in being admitted to Stuck's studio in the Munich Academy only after his second attempt, he would leave it a little more than a year later.

Kandinsky was only just beginning as an artist when he exhibited his painting *Evening* at the seventh exhibition of the Moscow Association of Artists (Kandinsky's participation was supported by that exhibition's hero, Viktor Borisov-Musatov). If alongside Borisov-Musatov's subtle and meaningful canvasses, Kandinsky's work did not seem out of place, how are we to imagine its sharing the same space with the works of Polenov or Bialinitsky-Birulia? At that time (February 1900), in the halls of the Stroganov Academy — a fifteen-minutes' walk from the Historical Museum, in which Kandinsky's painting was hanging — people crowded before the canvasses of his renowned teacher, Franz Stuck, viewing paintings that undoubtedly were the center of attention at the General German Exhibition. Kandinsky's early works drew fairly sharp criticism in Moscow.

Not meeting with particular approval anywhere and not yet feeling himself to be a professional, Kandinsky, despite everything, was imperceptibly and quite naturally transformed from an apprentice into a master. He was right when he sensed the incomprehension of both Russian and German critics: the former detected a pernicious "Munich influence"; the latter, "Byzantine influences." Strangest of all, he himself was capable of perceiving everything. Critics speak of the "polystylism" of early Kandinsky with some basis. The qualities of salon Impressionism, a hint of the dry rhythms of modernism (German Jugendstil), a heavy "demiurgic stroke" reminiscent of Cézanne (true, quite remotely), the occasionally significant echoes of Symbolism — all of these (and much more) can be found in the artist's early works. These qualities were characteristic of many young artists of the period.

From the outset Kandinsky painted like a mature artist, albeit an unskilled one. He tried his hand at a number of styles, on a number of different paths. But it was his own hand he tried, not that of anyone else. As early as the turn of the century, a critical mass of active information (visual and philosophical) had accumulated in Kandinsky's artistic consciousness. He was far from being interested in everything, but "all tongues" were, in fact, "known" to him. In his own development, Kandinsky passed through the entire history of culture, encompassing it within one destiny. His art was no stranger to the naive tale and to the highest flights of abstraction and decorative refinement. He came to his first significant works with a consciousness that was truly saturated, on the point of bursting.

11. *The Blue Mountain*, 1908-1909, Oil on canvas, 106 x 96.6 cm, The Salomon R. Guggenheim Museum, New York.

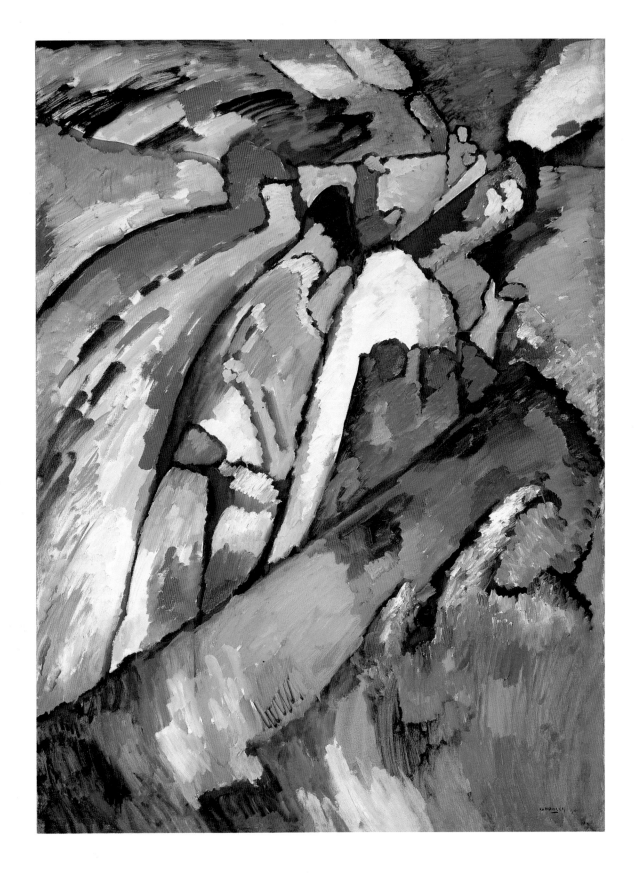

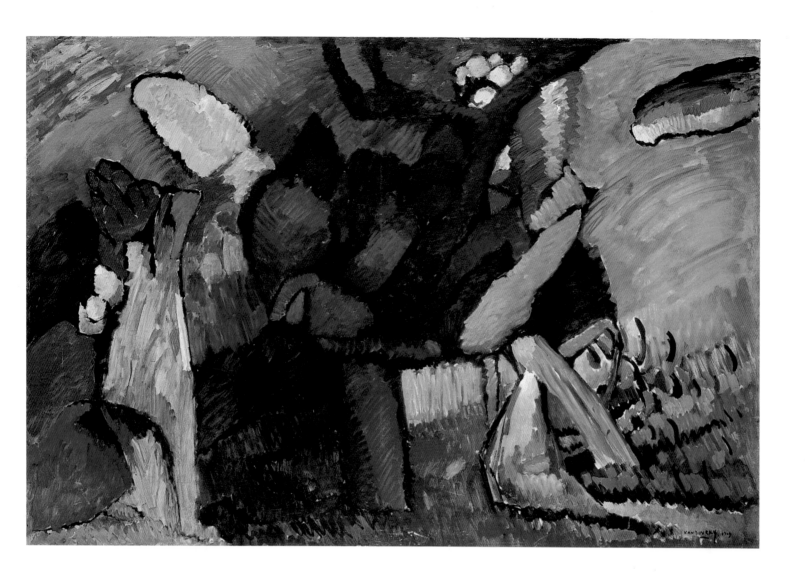

12. *Improvisation VII*,
 1909, Oil on canvas,
 Tretyakov Gallery,
 Moscow.

13. *Improvisation IV*,
 1909, Oil on canvas,
 108 x 158 cm,
 Museum of Fine Arts,
 Nizhni-Novgorod.

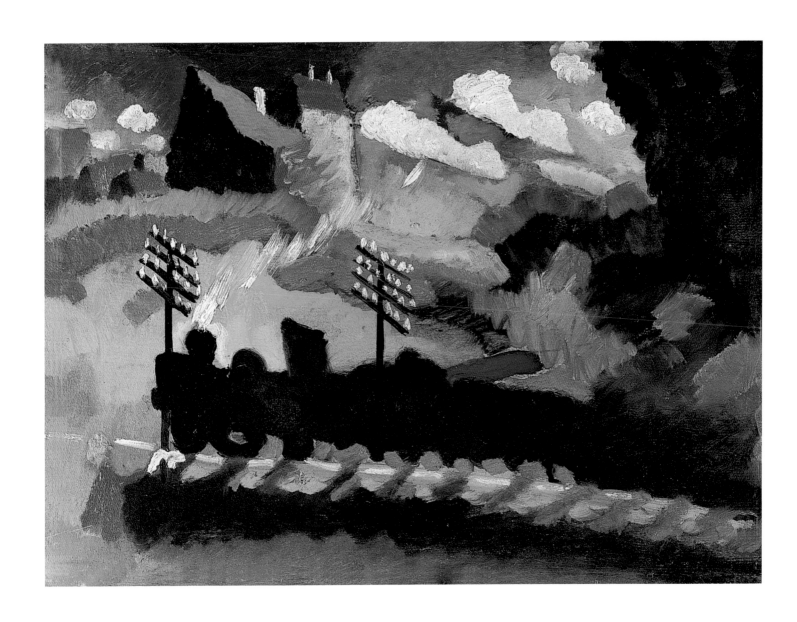

14. *Landscape Near Murnau
with Locomotive*, 1909,
Oil on cardboard,
36 x 49 cm,
Städtische Galerie im
Lenbachhaus, Munich.

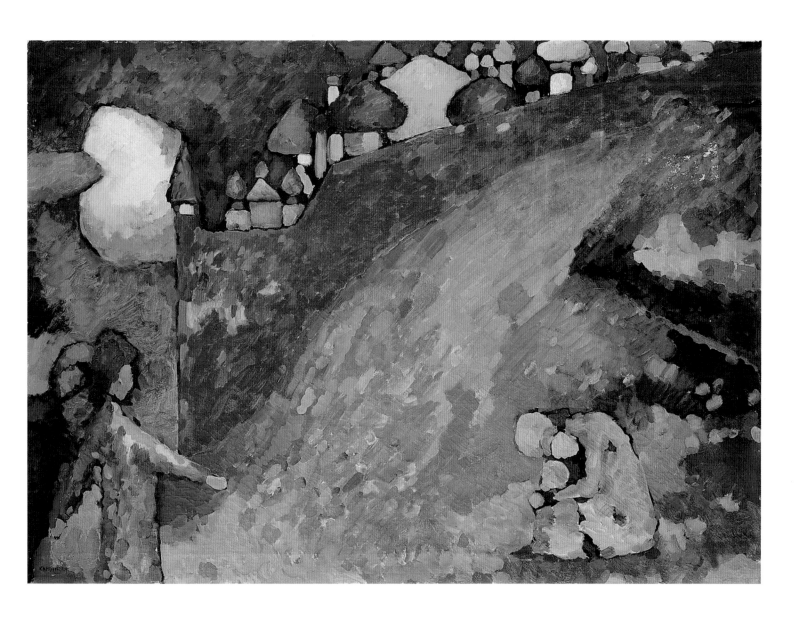

15. *Fatality*, 1909,
Oil on canvas,
83 x 116 cm,
Koustodiev Gallery,
Astrakhan.

The new Russian philosophy, the art of the icon, the genre of historical painting, modernism, the lucid strength of Impressionism, an understanding of the power of Matisse's color and Picasso's form and, most of all, his own insistent and intense meditations all informed a staggering readiness for self-realization. An openness "to all tongues" enabled Kandinsky to enrich himself without submitting to the influence of others. A knowledge of the art of Germany, France and Holland in the first decades of this century might have enslaved anyone else, but it only enhanced Kandinsky and inclined him towards contemplation.

Not yet capable of expressing the creative passion that was overpowering him, Kandinsky used life studies as a means of "fishing" for motifs which might become crucial elements in the realization of his as yet unclear aspirations. Thus, while still not a professional himself, he mustered the courage to found a new artists' organization in Munich, the Phalanx group. Soon afterwards, Kandinsky began teaching at an art school opened by the group. He did not teach the secrets of the higher artistic disciplines, but the fundamentals of the profession: drawing and painting. His pursuit of teaching was not the product of the benighted bravery of a narcissistic genius with no purpose in life, but rather was born of the desire to find himself in dialogue — if not with others of like mind, then with people who could be fascinated by the things which had fascinated him.

One very important aspect of creative work in the twentieth century — interpretation during the process of creation — apparently had a particular significance for Kandinsky. He worked together with his students in their search for truth. But desire, courage and talent were not enough. Kandinsky had to possess the vigor, conviction and authority that would make others see him as a true leader. At this point in his career, he had not yet painted anything which might have been called, if not a twentieth-century sensation, then at least a landmark designating the emergence of a fundamentally new trend in art. Apparently, however, was something in him that inspired trust. And what is more, it was Kandinsky's extraordinary pedagogical abilities that contemporaries noted. The Phalanx's authority became so great that such masters as Paul Signac and Felix Vallotton participated in the group's exhibitions. The works of Toulouse-Lautrec (who had died in 1901) were presented in Phalanx exhibitions as well. In the space of three years, Phalanx held twelve exhibitions, an unusually high number. Towards the end of this period, the German press began to speak seriously of Kandinsky. Giving his work the highest estimation, they cautiously and deferentially called his talent "original." He was invited to teach at the Kunstgewerbeschule in Dusseldorf. He participated in the 1902 exhibition of the Berlin Secession and, later, in the Salon d'Automne (where he became a jury member in 1905) and the Salon des Indépendants exhibitions in Paris.

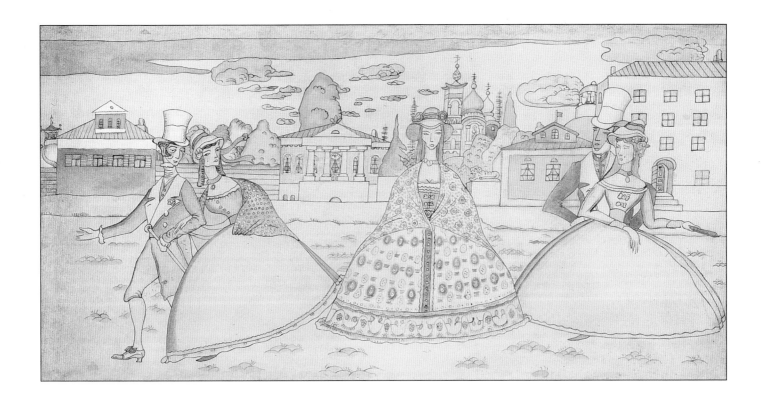

One could say that Kandinsky had acquired a reputation that was more elevated than stable and well-defined. One of the more important events determining Kandinsky's place in the artistic process of that time was his participation in an exhibition of the Dresden group Die Brücke (the Bridge), the first association of the Expressionists. The paintings and prints of these years are executed in a spirit of unrealized energy. They are capable of delighting, disappointing or exciting curiosity. There is much in them that is attractive, talented and fascinating. But in these works, the real Vasily Kandinsky is absent, or nearly so. Usually the first buds of something new ripen in an artist's soul long before the new thing becomes historical reality. History tells us, however, of certain moments of culmination, "shining hours," when searches that have quietly smoldered for years suddenly flare up like comets. The middle of this century's first decade was saturated with such events: the first exhibit of the Fauves at the 1905 Salon d'Automne; the founding in the summer of that same year of Die Brücke; and finally, the stormy and shocking manifesto not only of Cubism, but of a wholly new vision — Picasso's *Les Demoiselles d'Avignon* (1907). The work that Kandinsky produced in Murnau at the end of this decade was another such "moment of truth."

16. *Ladies in Crinolines*, 1909, Oil on canvas, 96.3 x 128.5 cm, Tretyakov Gallery, Moscow.

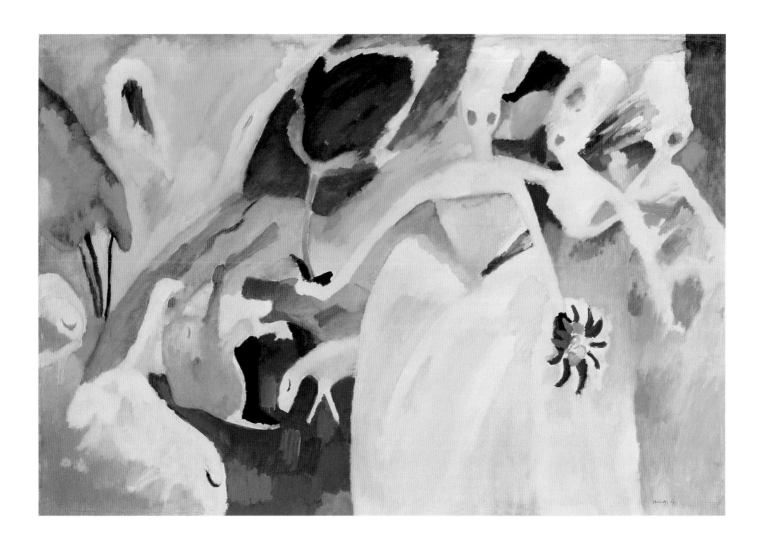

17. *Pastorale*, 1911,
 Oil on canvas,
 105 x 156.7 cm,
 The Salomon
 R. Guggenheim
 Museum, New York.

18. *Improvisation XX*, 1911,
 Oil on canvas,
 The Pushkin Museum
 of Fine Arts, Moscow.

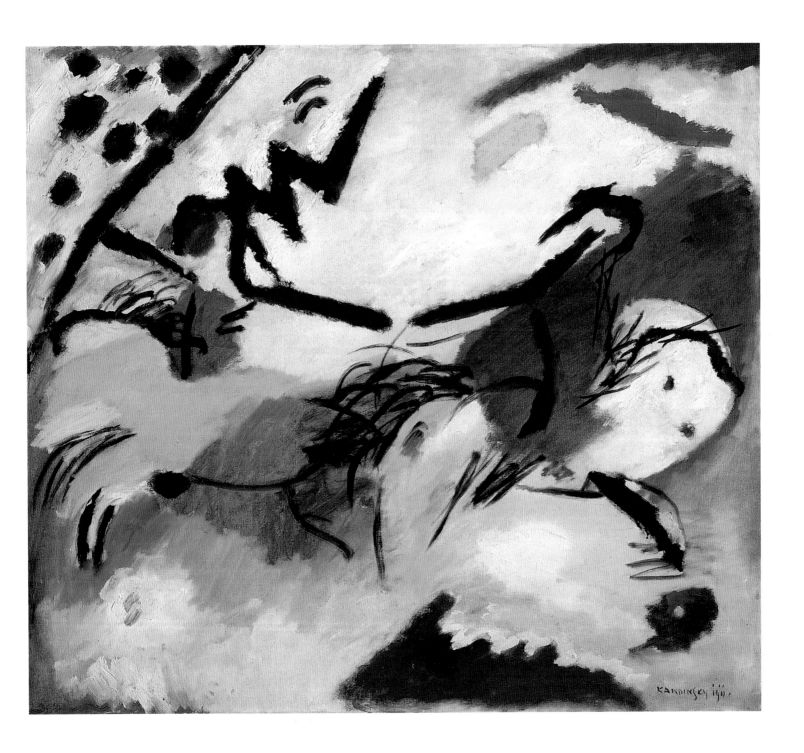

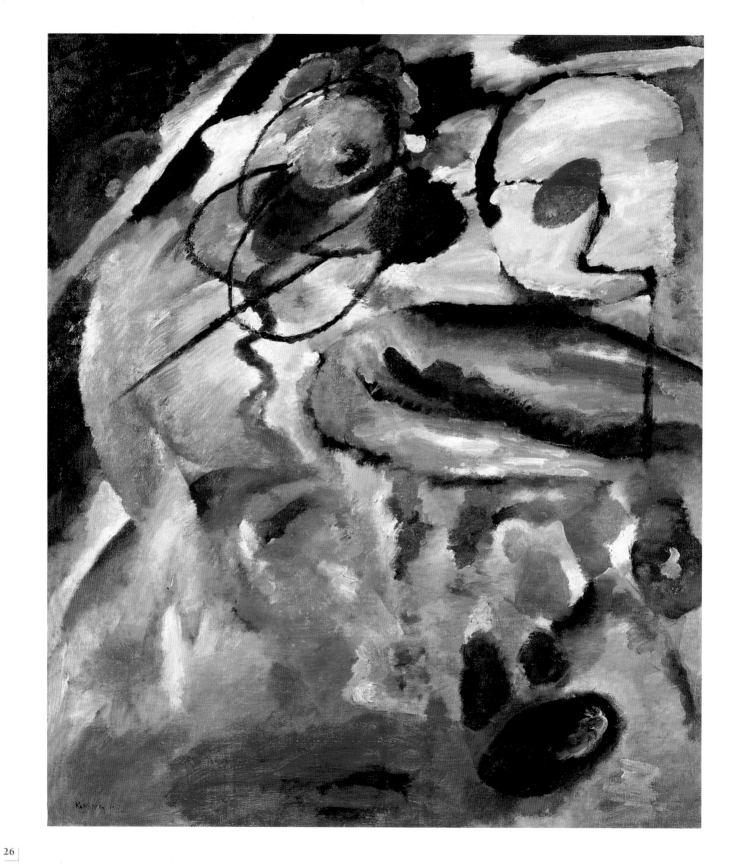

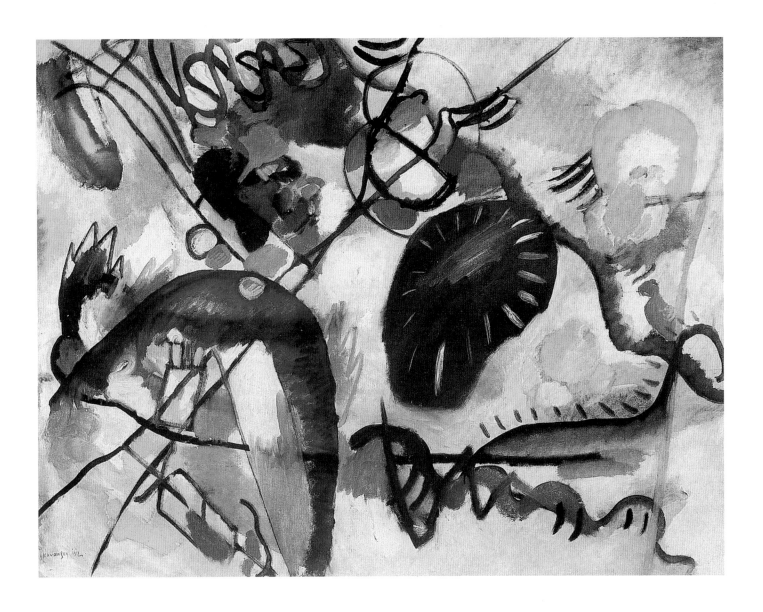

19. *Picture with a Circle*,
 1911, Oil on canvas,
 200 x 150 cm, Museum of
 Fine Arts, Georgia.

20. *Black Spot I*, 1912,
 Oil on canvas,
 100 x 130 cm, The State
 Hermitage, St. Petersburg.

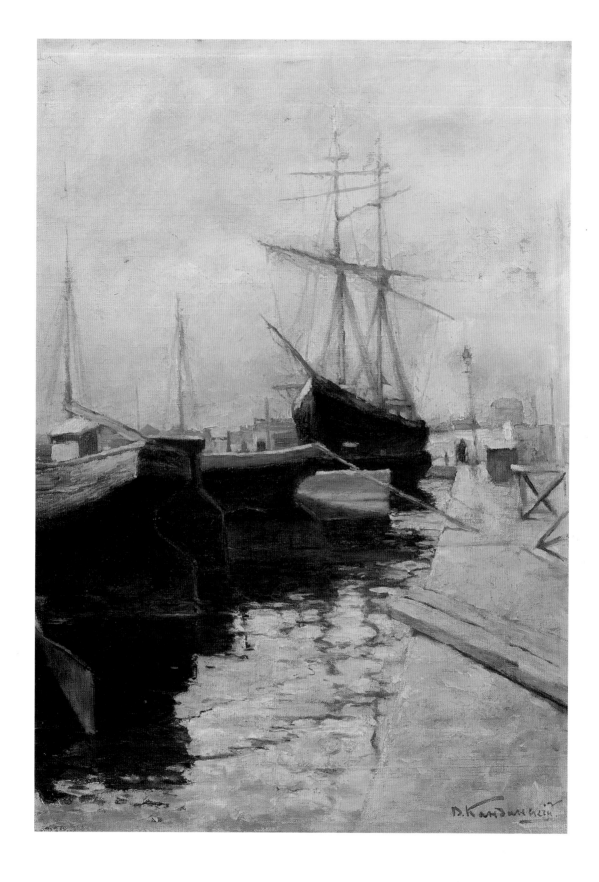

There are few moments (if any) in the history of art as dramatic and magnificent as Kandinsky's coming into his own in Murnau. As a rule, an artist arrives at the creation of an individual style or a new direction in several stages. Even Picasso's development was relatively gradual. Kandinsky's evolution was marked, of course, by such gradual steps as well, but it is unlikely that any other artist has experienced the same bright explosion or the same release of energy after years of agonizing artistic inarticulateness. The object world was for Kandinsky both a source of artistic ideas and a fetter: he was not striving to create a new language for the sake of itself. Like Cézanne and Hemingway (who studied clarity of self-expression from the former's paintings), Kandinsky wanted only to become himself, without yet knowing what it was he wanted to become. Only one thing was obvious: his aspiration to an absolute, all-conquering individuality and a synthesis, perhaps even a syncretism, of the arts. He discussed music and poetry as often as he did painting. But it was precisely in the graphic arts where the breakthrough took place. The oft-cited passage from Kandinsky's writings where he speaks of landscapes which agitated him "like the enemy before a battle" and conquered him is indeed very telling. While nature held sway, it attracted the artist with the undisclosed secret of its harmonious dramas — dramas camouflaged by reality.

Nature's charm enthralled Kandinsky, thus hindering him from passing "through it"; he sought "the gaze of reality." The word zazerkalye ("the land behind the looking glass" — the title of the Russian translation of Carroll's *Through the Looking Glass*) has taken root in Russian translation tradition. It is a wonderful find, a new metaphor for our twentieth-century literature. Despite this, the title of Lewis Carroll's book in the original English had been forgotten. While not as splendid, this title has a somewhat different sense. As an important phenomenon in art, as an "instrument of the metaphor of plasticity," the mirror has been used by artists since time immemorial: the mysterious mirrors of the old Dutch masters, concentrating the great within the small or serving as incarnations of the Madonna; the mirror of Velázquez's Venus; the royal couple in Goya's painting with its stunning "effect of self-contemplation"; the *Mirror* of Marc Chagall; Dostoevsky's *Doubles*; and Kandinsky's own linoleum cut *Mirror* (1907, Städtische Galerie im Lenbachhaus, Munich) (p.13), its strange, powerful sketchiness enclosed within an affected rhythmics in the Jugendstil manner. For the twentieth-century artist, reality likewise becomes that cunning mirror whose amalgam does not allow him to penetrate into "the land behind the looking glass," the only thing that he seeks. The swiftness with which Kandinsky made the transition from his Murnau discoveries to pure abstraction (a space of no more than two years) testifies to this aspiration. "Transition" is putting it mildly. It was an outlet, a breakthrough, so long awaited and desired.

21. *The Port of Odessa*,
c. 1898,
Oil on canvas,
65 x 45 cm,
Tretyakov Gallery,
Moscow.

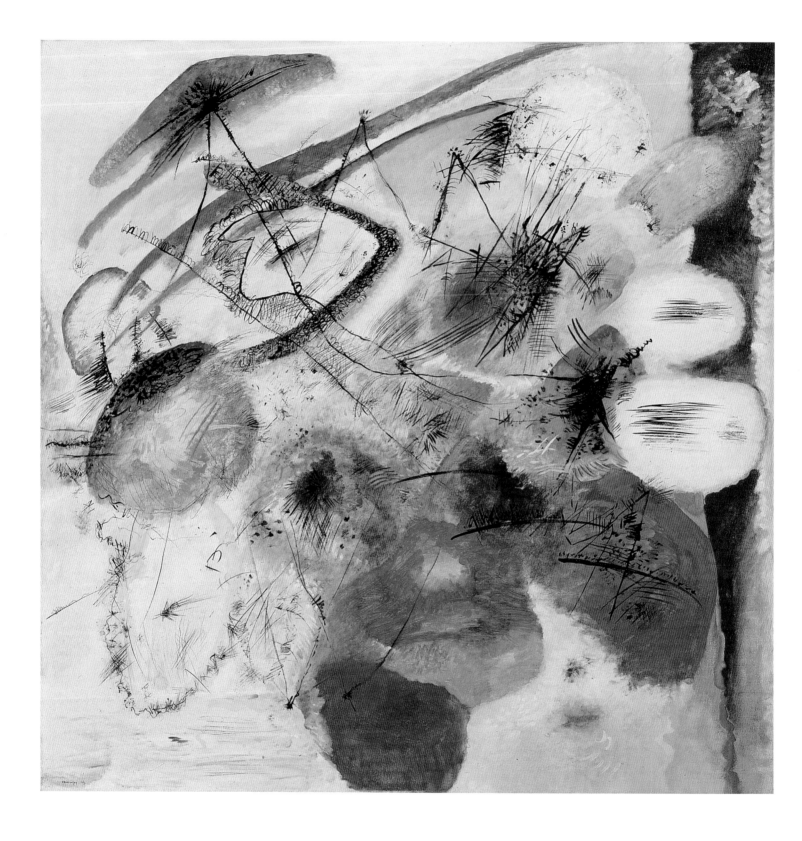

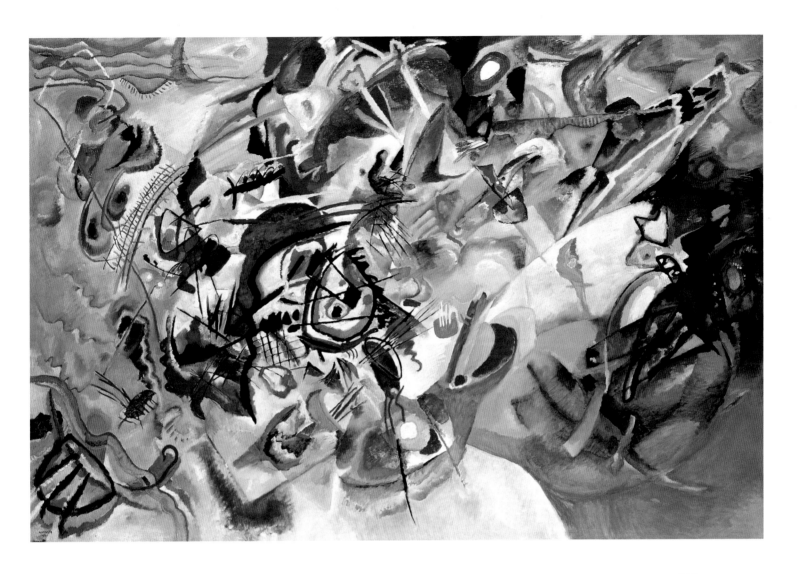

22. *Black Lines I*, 1913,
 Oil on canvas,
 129.4 x 131.1 cm,
 The Salomon R.
 Guggenheim Museum,
 New York.

23. *Composition VII*, 1913,
 Oil on canvas,
 200 x 300 cm, Tretyakov
 Gallery, Moscow.

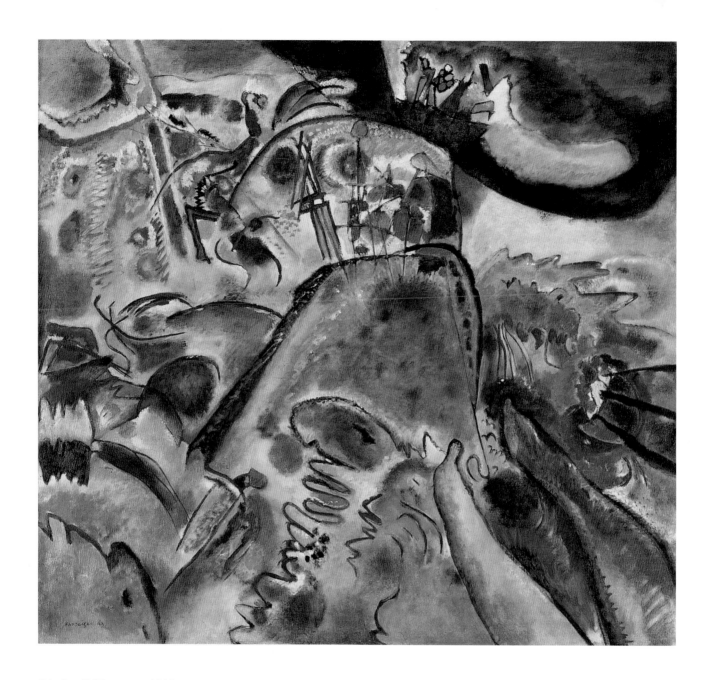

24. *Small Pleasures*, 1913,
 Oil on canvas,
 109.8 x 119.7 cm,
 The Salomon R.
 Guggenheim Museum,
 New York.

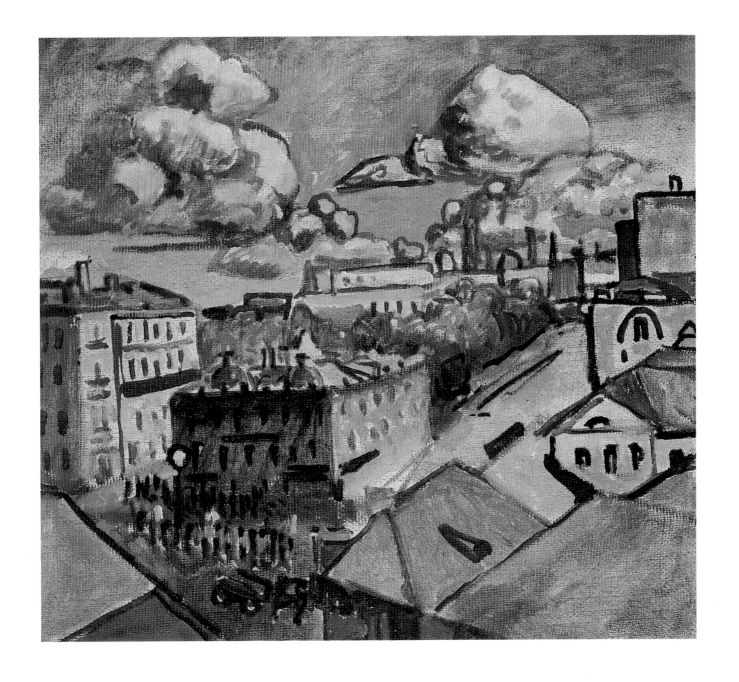

25. *Moscow, Zubovsky Square*,
c. 1916,
Oil on cardboard,
34.4 x 37.7 cm, Tretyakov
Gallery, Moscow.

Kandinsky began working in Murnau in August, 1908. The intensity with which he worked during this period is stunning. He made sketches for theatrical performances that he intended to realize with the composer Thomas von Hartmann and the dancer Alexander Sakharov; he made plans for a musical "Album" in which his prints would share the same space with the music of Hartmann; he engaged in theoretical investigations; he prepared for the organization of yet one more artists' group, the Neue Künstlervereinigung München (New Artists' Association of Munich), whose president he would become the following year. But most importantly, during this time a revolution took place both in his own art and in world painting, one with few equals and which, in its staggering significance, could be regarded as a sort of historical "master class," a lesson of courageous self-knowledge.

The artist's gaze broke through the amalgam of reality that previously had sent him stable pictures of the objective world. He saw the secret rhythms of color, line and form. Kandinsky's transition from the object world to the world of pure forms was predetermined by his earlier trials and can hardly be interpreted either as a loss or an acquisition. It is a given, without which he would never have become himself. In his early Murnau landscapes it is not hard to recognize a Fauvist boiling of colors and an abruptness in their juxtapositioning, the dramatic tension of Expressionism (which was gathering strength at that time), and the insistent texture of Cézanne.

What is surprising, however, is that this recognition is purely rational, a kind of "intellectual correctness" on the part of the experienced viewer. It is quite apparent that Kandinsky did not construct his vision on the discoveries of his older contemporaries. For him, their art was part of the intelligible world and "Fauvist patching" was a part of reality. Through it, he rushed into his own world, a world that was still only half-open.

The breakthrough of the outward appearance of the Murnau landscapes was for Kandinsky an entry into the emotional and spiritual essence of the universe. For the Fauves, painting was a means of free self-expression, a parade of painterly license. Through the trees, mountain slopes and roads of Murnau and through its completely unfamiliar landscapes, the artist saw his painful past searches and a way into the future, into his own higher world, a world hidden for so long behind the all too material amalgam of objective reality. He saw an outlet into a world he had not seen before, but whose existence he had guessed at and known as the sublime and principal reality. Soldered onto the canvas and, at the same time, bursting free of their material substance, the patches of color glimmer like living, breathing matter.

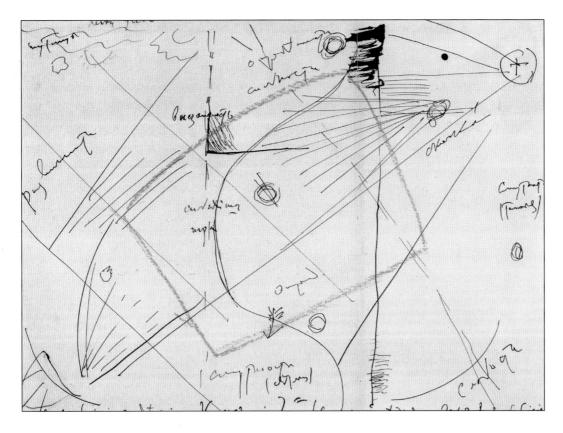

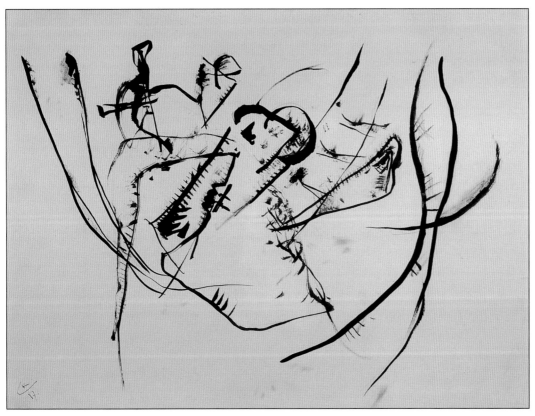

26. Analytical Drawing
 for *Composition VII*,
 1913.

27. *Composition,
 Landscape*, 1915,
 Watercolor, India ink
 and white on paper.
 Russian Museum,
 St. Petersburg.

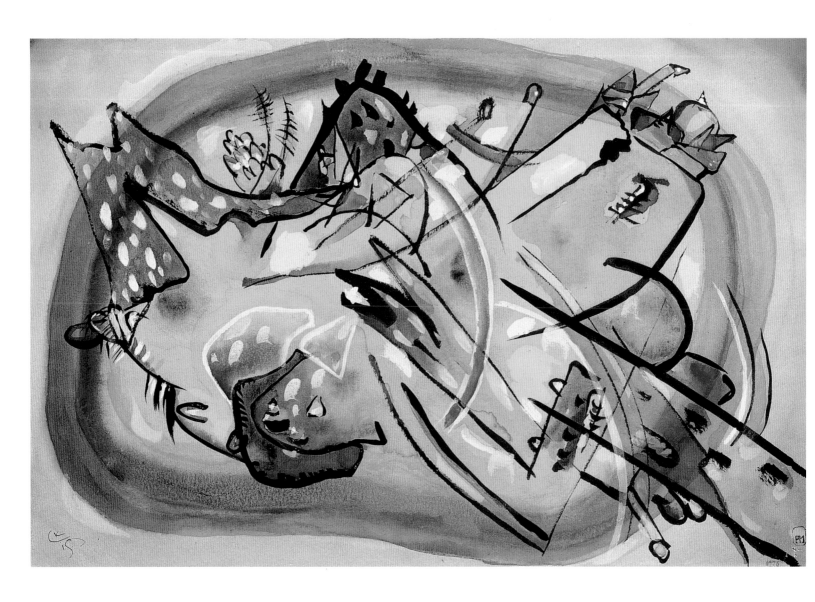

28. *Composition, Landscape,*
 c. 1916, Watercolor,
 India ink and white on
 paper, Russian Museum,
 St. Petersburg.

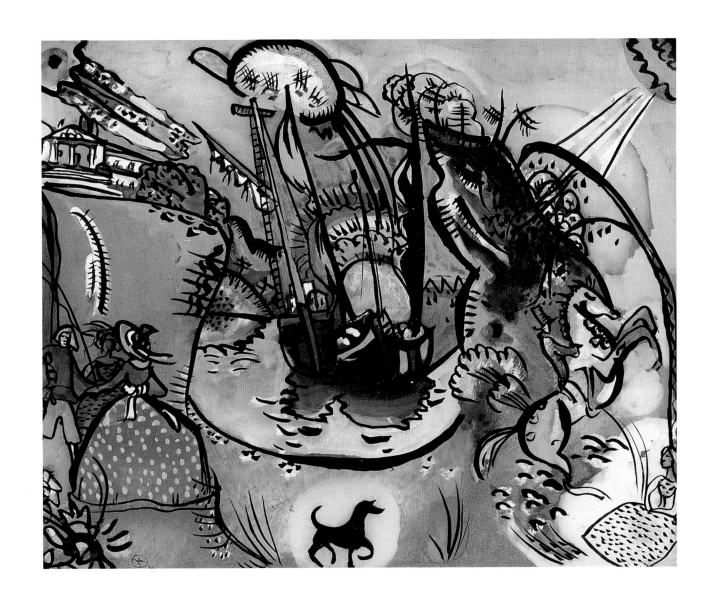

29. *Harbour*, 1916,
Oil on foil, glass,
21.5 x 26.5 cm,
Tretyakov Gallery,
Moscow.

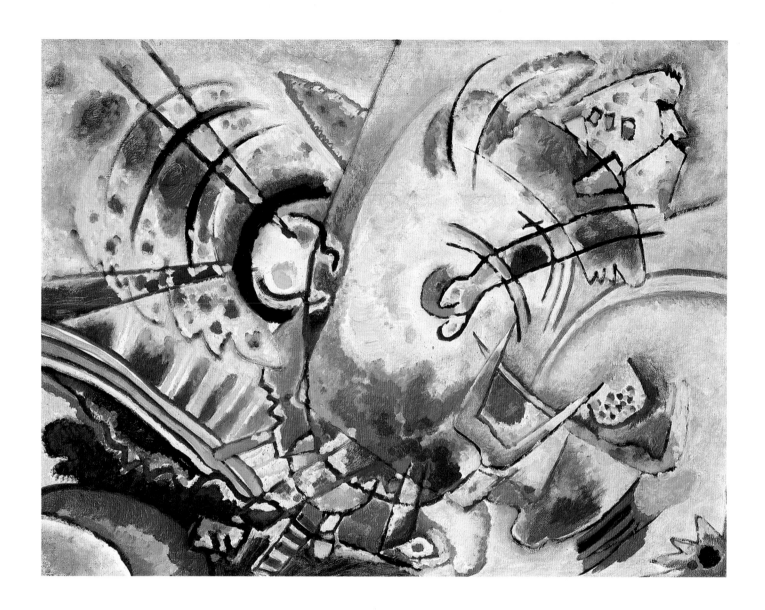

30. *Untitled*, c. 1916,
 Oil on canvas,
 50 x 66 cm, Museum
 of Fine Arts, Krasnodar.

31. *Moscow, Red Square*,
 1916, Oil on canvas,
 51.5 x 49.5 cm,
 Tretyakov Gallery,
 Moscow.

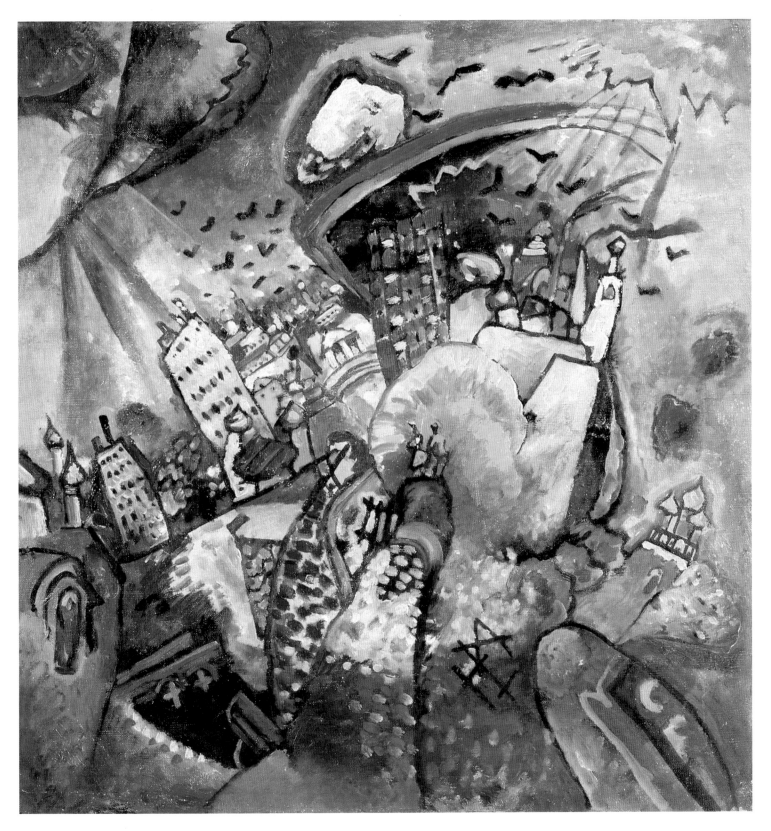

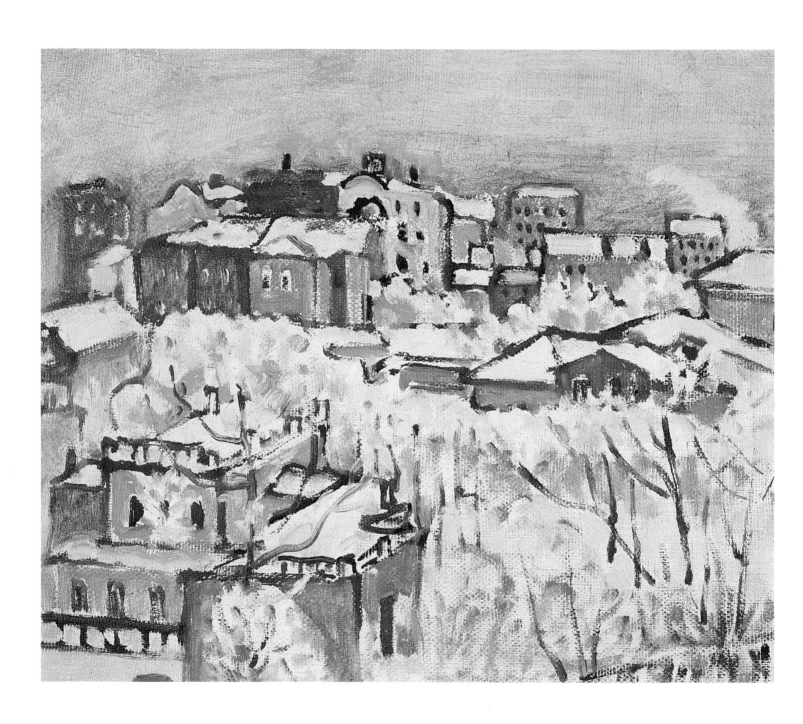

In passing, they recall the objects which they signify, but persuade our gaze and our consciousness that the yellow triangle, with its ragged outlines and black lacunae, has an incomparably higher and more significant value than the corner of the building it marks; that the alarmingly scarlet trapezium in the foreground, although it signifies the roof of a house, has a special, separate, sacred and endlessly beautiful meaning (Murnau, 1908, Tretyakov Gallery). In the Murnau landscapes it is as if the viewer is present at the act of creation, at the birth of a new form of painting, one that, while still designating the world, is already detaching itself from it. A kind of solemn parting with the material world and the entry into a different world, a spiritual and liberated world, take place (*Summer Landscape*, 1909, Russian Museum) (p.15).

Among Kandinsky's predecessors and contemporaries a kind of dialogue between reality and art had been preserved, and within its field of tension an "artistic sacrament" was enacted. The classic example of such a dialogue was Cézanne's ability (as noted by Herbert Read) to distinguish the structural configuration of objects from the objects themselves. Kandinsky himself was leaving behind the earthly gravitational field of objects for the weightlessness of the abstract world, where the principal coordinates of being — up, down, space, weight — are lost. According to the myths (or revelations) of the twentieth century, by leaving reality behind, Kandinsky renounced illusion and, therefore, drew closer to a higher reality. Could it be that one of the fundamental paradoxes of the end of the millennium (a paradox to a great degree created by Kandinsky himself) lies in this? Kandinsky came back to Russia on two occasions. His first (relatively short) visit to Moscow took place from October to December, 1912. The second stay, a much longer one, kept the artist in Russia from December, 1914, to December, 1921.

Kandinsky arrived in his native city at a time of "unheard-of changes and unprecedented revolts" (Alexander Blok). The artist himself knew no peace. The upward flight at Murnau had brought no certainty: the breakthrough to abstraction had not become final. Kandinsky wavered between what he had acquired and what he was in the process of acquiring. In these vacillations, however, one senses neither emotional strain nor cold calculation. It was simply his old desire to try "all tongues" again and again before settling on a single path. Perhaps he was lonely in the cold winds of the absolute freedom he had found? He had already become well-known in the West. In 1911, the Blaue Reiter (Blue Rider) group had been founded; an anthology bearing that name, the Blaue Reiter Almanach, was published by Piper Verlag the following year. (The book included artwork and essays by Blaue Reiter members, as well as articles on contemporary music by representatives of the so-called Second Viennese School including Arnold Schoenberg, Alban Berg and Anton von Webern.)

32. *Winter Day. Smolenski Boulevard*, c. 1916, Oil on canvas, 26.8 x 33 cm, Tretyakov Gallery, Moscow.

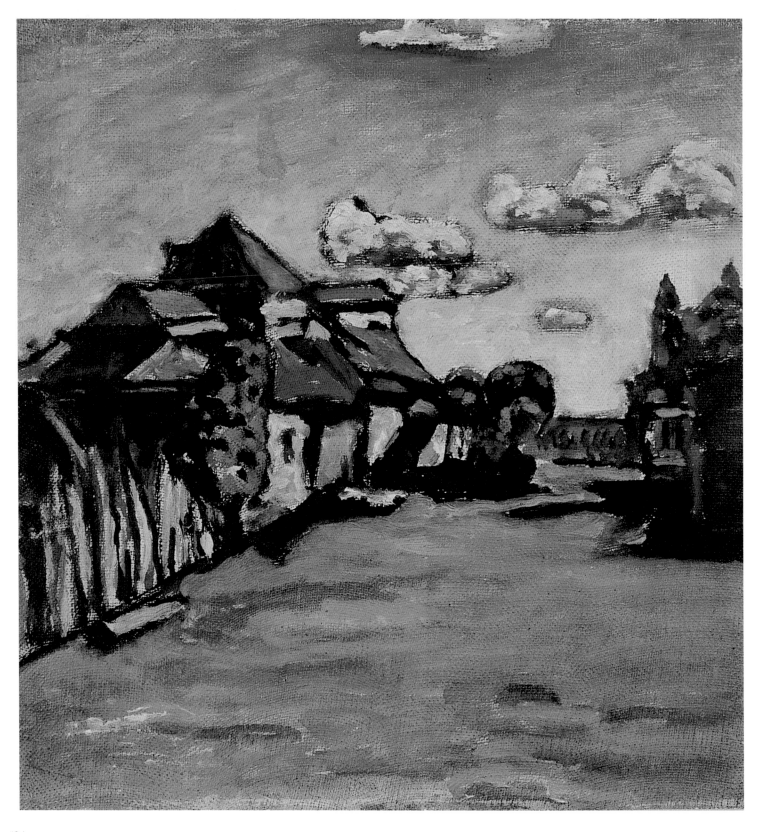

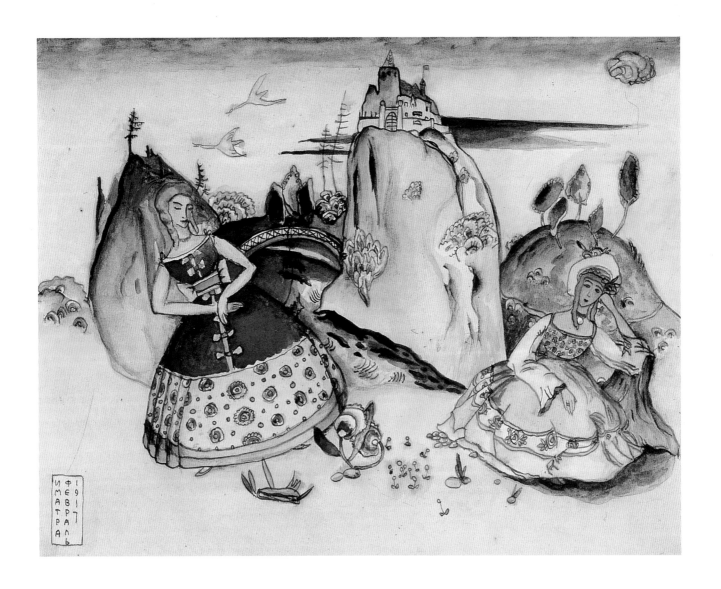

33. *Suburbs of Moscow*,
 c. 1916, Oil on canvas
 mounted on cardboard,
 26.2 x 25.2 cm, Tretyakov
 Gallery, Moscow.

34. *Imatra*, 1917, Watercolor
 on paper, 22.9 x 28.9 cm,
 Pushkin Museum of Fine
 Arts, Moscow.

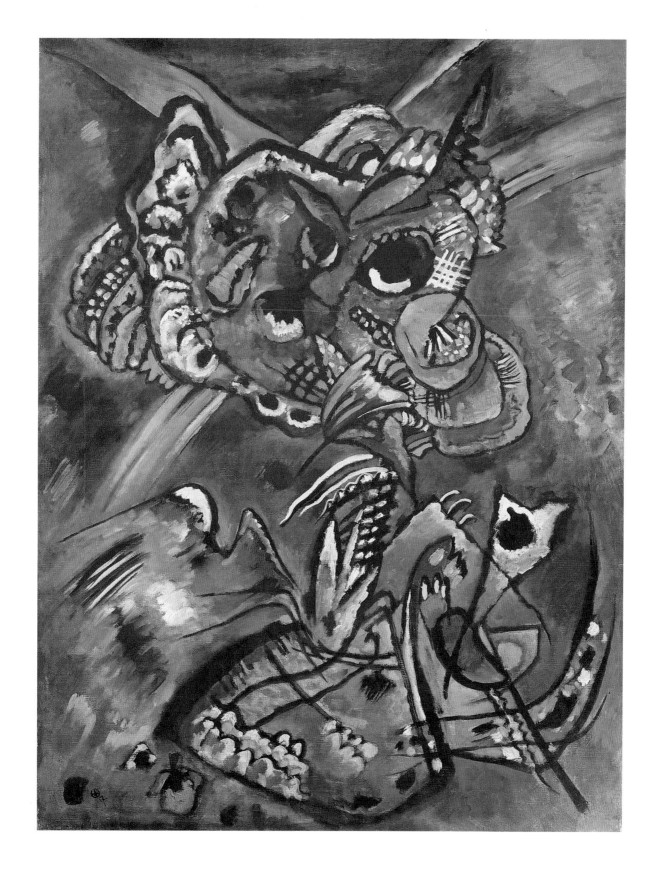

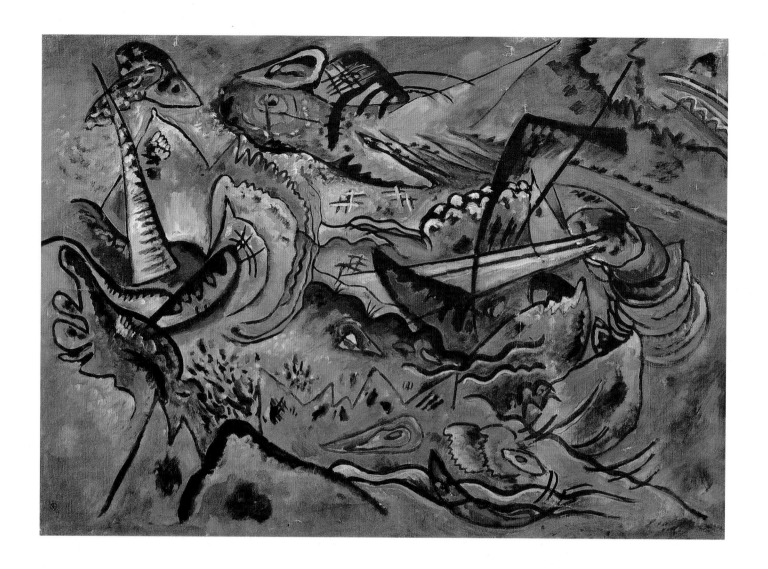

35. *Twilight*, 1917,
 Oil on canvas,
 91.5 x 69.5 cm,
 Russian Museum,
 St. Petersburg.

36. *Southern*, 1917,
 Oil on canvas,
 72 x 101 cm, Art
 Gallery, Astrakhan.

At the group's first show, in Munich's Tannhauser Gallery, Kandinsky exhibited more than forty works. Besides paintings by the group's members, works by Delaunay and Henri Rousseau were exhibited, as well as attempts by the composer Arnold Schoenberg in that genre. Kandinsky was at the center of the Expressionist movement in Germany. At his side were other world-class talents, including his longtime confederate Alexei Jawlensky (with whom he had worked in Murnau), August Macke, Paul Klee, and Franz Marc. In early 1912, the Second Blaue Reiter exhibition was held, with the Russian artists Natalia Goncharova, Mikhail Larionov and Kazimir Malevich taking part.

Kandinsky had already acquired a name in his homeland, Russia. His *Concerning the Spiritual in Art* was known from lectures and other accounts (the book was published during Kandinsky's first visit, in December, 1912). His articles were published in such Russian journals as *Apollon* (Apollo) and *Mir Iskusstva* (The World of Art). His works were on view in a number of Russian cities, including St. Petersburg. The paintings exhibited at the so-called International Salon of 1910-1911 — *Fatality* (1909, Kustodiev Astrakhan Picture Gallery) (p.21) and *Ladies in Crinoline* (1909, Tretyakov Gallery) (p.23) — represent a complex and powerful blending of living landscape, passéist Russian motifs, Symbolist mirages and triumphant abstraction. At the same exhibition he presented his Improvisations, works practically free of materiality (*Improvisation IV*, 1909, Nizhni Novgorod State Art Museum (p.19); *Improvisation VII*, 1909, Tretyakov Gallery) (p.18).

Kandinsky was a participant in the first Knave of Diamonds exhibition (1910), where works similar to these were displayed. He had become, perhaps, one of the first stable transnational artists. Kandinsky had always paid close attention to the Russian art scene, and now his sympathies were on the side of Aristarkh Lentulov, David Burliuk and, to a significant degree, with Larionov and Goncharova. Kandinsky had been and remained a free artist — he never became hostage to his own theoretical conceptions. Many might have been taken aback by the romantic ingenuousness of his wholly figurative Moscow landscapes. This ingenuousness is only apparent, however. It is as if the artist were trying to catch sight of and to realize a real cityscape as it unfolds in space and time (memories of the artist's own youth) with the aid of the new "optics" which had emerged in Murnau.

Houses, clouds, trees, the snowy fog: these things arise in the paintings as if from the parts of a kind of "non-figurative mosaic." An asymmetrical process to what happened at Murnau appears: a likeness of earthly reality is constructed from "non-figurative" elements. The primary formulae of color blocks here is not the outcome of artistic insight, but rather becomes, a new instrument for understanding the world (*Moscow. Zubovsky Square*, c. 1916, Tretyakov Gallery (p.33); *Winter Day. Smolensk Boulevard*, c. 1916, Tretyakov Gallery) (p.40).

37. *Composition*, 1916,
Oil on canvas,
Art Gallery, Tjumen.

38. *Grey Oval*, 1917,
Oil on canvas,
104 x 134 cm, Picture
Gallery, Ekaterinburg.

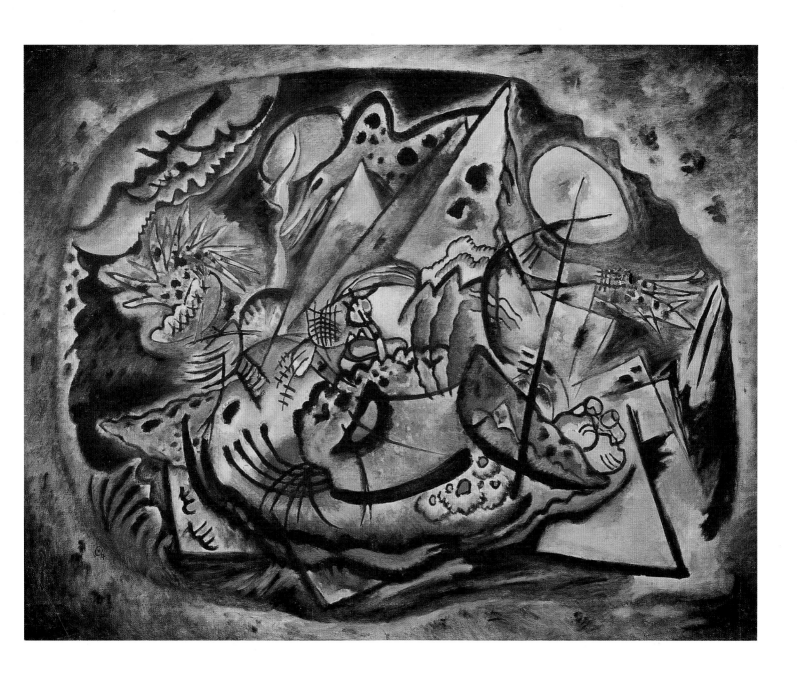

39. *Amazon*, 1918,
Glass painting,
32 x 25 cm,
Russian Museum,
St. Petersburg.

40. *Rose Knight*, 1918,
Glass painting,
Russian Museum,
St. Petersburg.

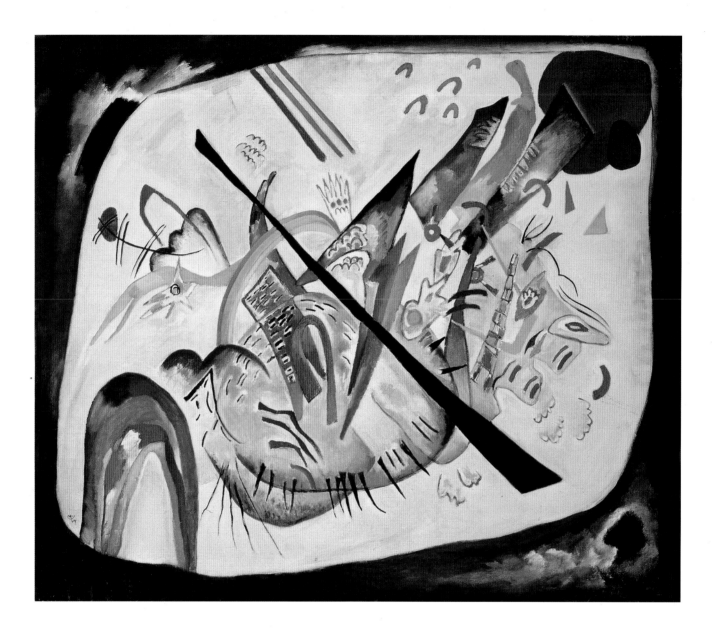

41. *White Oval*, 1919,
Oil on canvas, 80 x 93 cm,
Tretyakov Gallery, Moscow.

42. *Woman in a Gold Dress*,
c. 1918, Oil on foil, glass,
17.3 x 16.1 cm, Tretyakov
Gallery, Moscow.

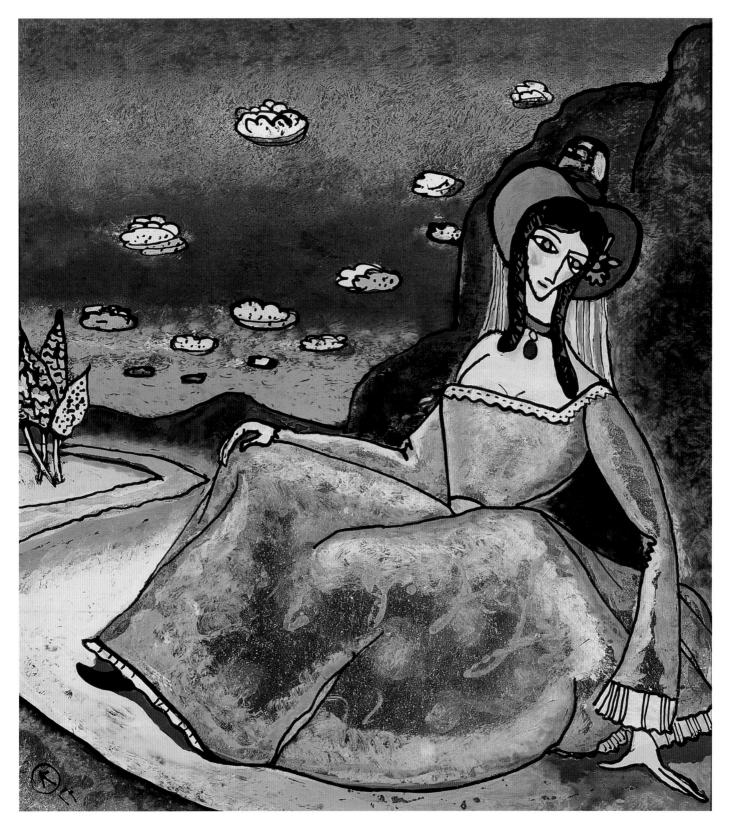

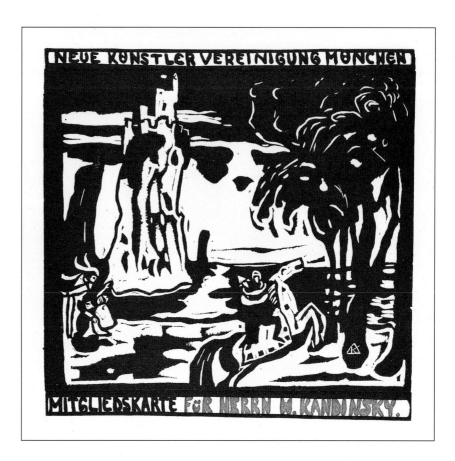

43. *Painting with Points,*
 1918, Oil on canvas,
 126 x 95 cm,
 Russian Museum,
 St. Petersburg.

44. *Engraving III*, 1918,
 13.5 x 16 cm.

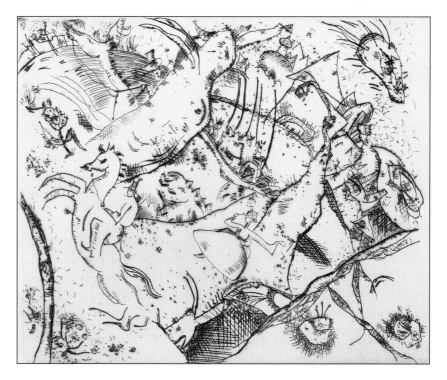

The transnational context in which Kandinsky was at home introduces the sensation of a falling world, devoid of horizontals and verticals, into his paintings (e.g., *Moscow. Red Square*, 1916, Tretyakov Gallery), a sensation characteristic of the works of Delaunay and Chagall during this same period. His non-figurative compositions from the teens of this century were of primary importance for the future, a decisive step into that world of the spirit to which Kandinsky had aspired for so long and with such determination. He was already in his fifth decade. None of the titans of the avant-garde had ever come into his own at such a late age in life. Vladimir Solovyov had written as early as 1890 that one of the fundamental principles of art "is the transformation of physical life into spiritual [life]." And although since the time of Plato many philosophers had written more or less about "spirituality" as a particular category of art seemed at this time to be an almost new phenomenon and occupied Kandinsky as nothing else did. It was not without reason that Kandinsky dedicated his principal written work, *Über das Geistige in der Kunst* (*Concerning the Spiritual in Art*), to this problem.

Like the majority of modernist artists, Kandinsky was unable to conceive of his work without theory and interpretation. There was no one who aspired to synthesis as Kandinsky did, but likewise there was no one who so ably conceived so many fascinating philosophical tracts and paintings and esthetic revelations. Of course, the constant parallels with music of which Kandinsky made use (in this he was not alone), thus showing the kinship of expressive means, are most likely dated. Music had always expressed without depicting. The viewer subconsciously looks for (and finds) space, volume and associations with the object world in a picture (no matter how "abstract" it is). Color is hardly divisible from the object; what is more, it prompts associations with the object even when the artist does not intend this. The exit into abstraction is never complete, but the road to it is of primary value to art.

Complete weightlessness is probably impossible as well: having broken free of the earth's gravity, objects (like planets in the universe) begin to gravitate towards each other. Strictly speaking, Kandinsky depicts a similar process. In his *Compositions* and *Improvisations* (in which the artist is almost liberated from weight and space) two poles emerge of the argument with the world of things. It goes without saying that Kandinsky's "textbook" abstract works are fed by a powerful and complicated system of roots, encompassing much of which we have already written, including the art of the Russian icon. But in the mature, wholly non-figurative works, the origin is hidden in the deep underground, thus allowing the artist to escape "from probability into rightness" (Pasternak). No one has described better that eternal arabesque of associations than the champion of committed and moral art, Leo Tolstoy.

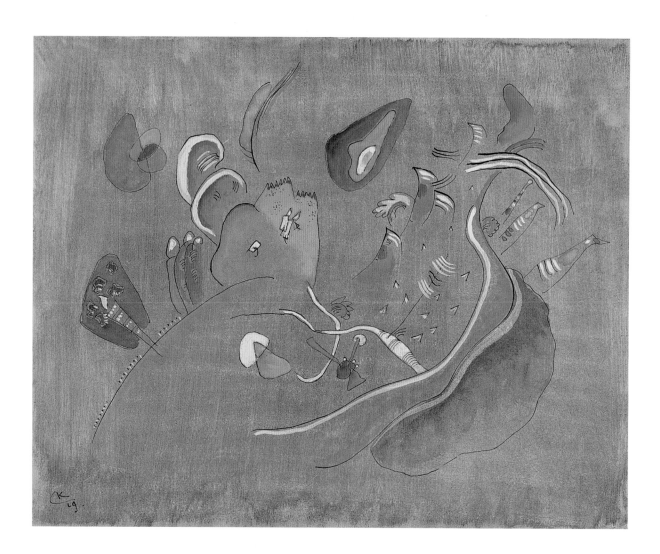

45. *Composition on Brown*,
 1919, Watercolor, India
 ink, pen and white on
 paper, Pushkin Museum
 of Fine Arts, Moscow.

46. *Red Oval*, 1920,
 Oil on canvas,
 71.5 x 71.2 cm,
 The Salomon
 R. Guggenheim
 Museum, New York.

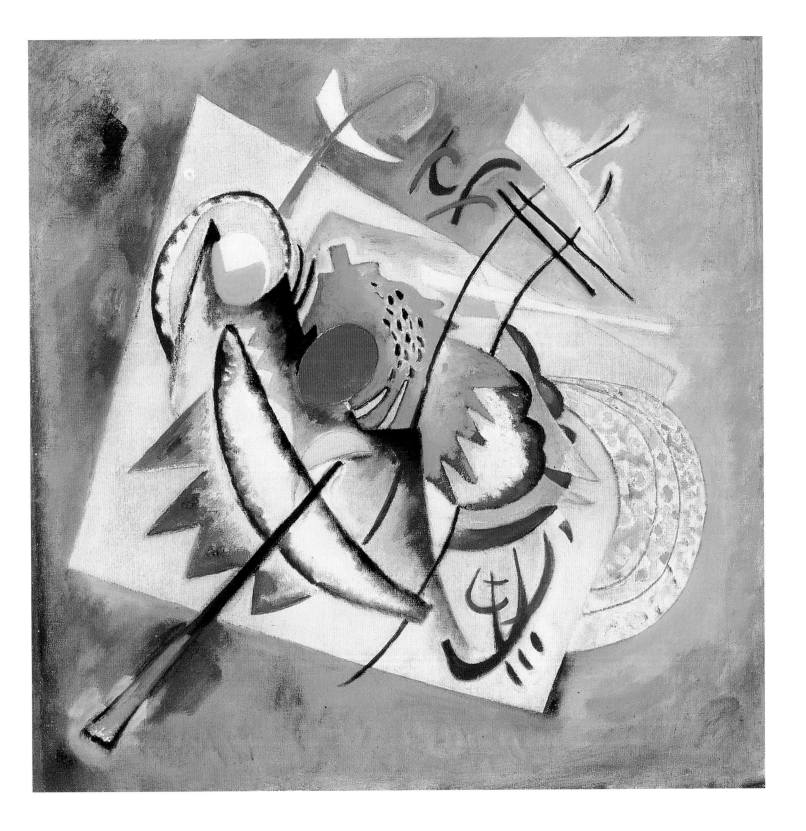

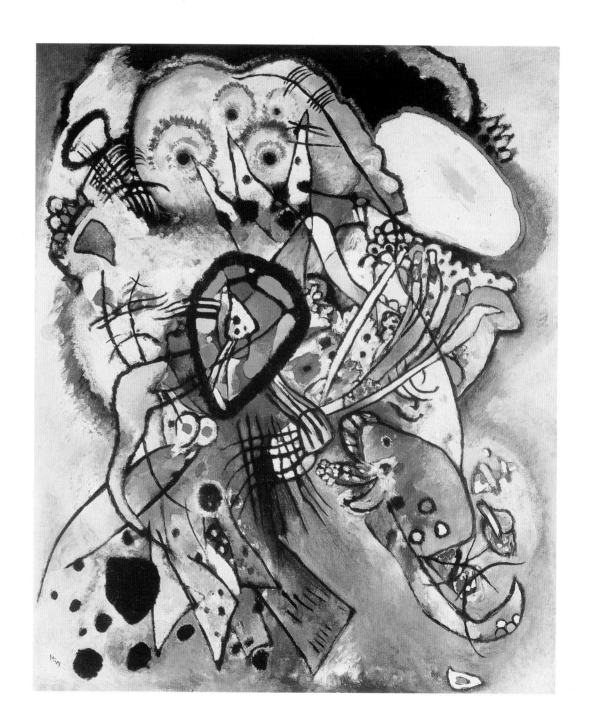

47. *Two Ovals*, 1919,
 Oil on canvas,
 107 x 89.5 cm,
 Russian Museum,
 St. Petersburg.

48. *On White*, 1920,
 Oil on canvas,
 95 x 138 cm,
 Russian Museum,
 St. Petersburg.

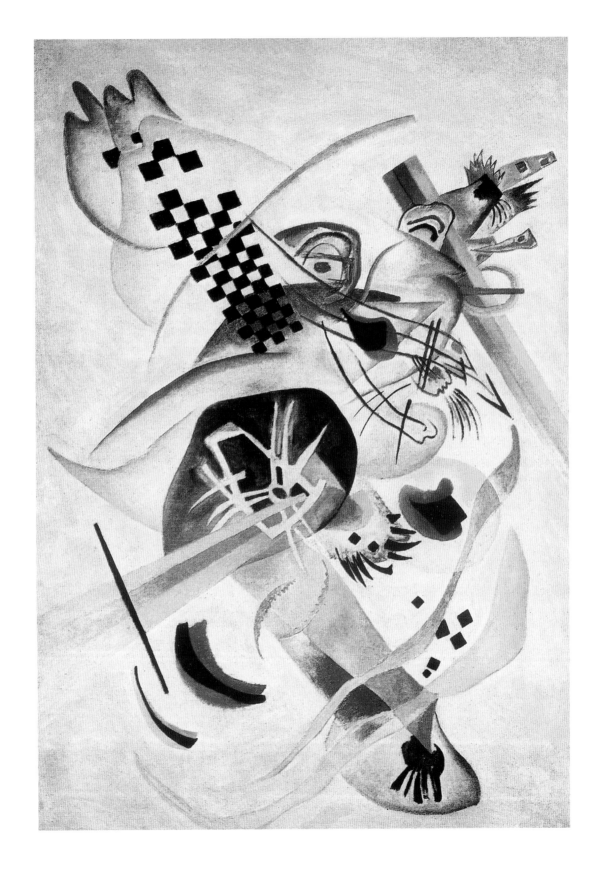

All these things had been alive in consciousness, had been fleetingly glimpsed in art, but as something strange, "other", something still awaiting a genuine artistic discovery. In mid-1910, Kandinsky brought a cyclopean and hitherto unseen universe crashing down onto the artistic consciousness of viewers and his own colleagues. Up until this time there had been very little abstract painting. Malevich's experiments for the most part were interpreted as artistic manifestos rather than the emotional plasma, the visual lava, of modernist culture. It was from the paintings of Vasily Kandinsky that this lava came pouring forth. His early non-figurative compositions were by no means greeted as a joyous revelation (even the sunny and artless Impressionists were accepted slowly and unwillingly, after a number of scandals). These works were as piquant and unusual as the first spices, the first opium, hops and tobacco smoke. They were as the first rhymes, the first organ and the first moving picture. They were what people had lived without for ages; but, once they had experienced these new sensations, they began to wonder how it was that they had lived without them before.

Non-figurative paintings provided art with a new environment: now that it was able to demonstrate and to comprehend its naive weaknesses, as well as its eternal prerogatives, figurative art began to exist as an ever-present alternative. Vasily Kandinsky's abstractions are filled with a coded, impersonal, "organic" life. At times in Kandinsky's abstract forms, likenesses of anthropomorphic and zoomorphic apparitions become visible, and the "artistic substance" in his paintings is invariably mobile. But, first and foremost, his pictorial world (as opposed to Malevich's) never gravitates towards weightlessness, towards "absolute zero" and absolute harmony. "There is no absolute," writes Kandinsky. His world is in the process of becoming. On the threshold of a new millennium, Kandinsky's worlds summon up associations with the problems of the beginning of this century, the problems out of which his art grew.

These "depicted" emotions, this visible subconscious, approximate what would begin to emerge in the second half of the twentieth century. Unfortunately, we are not quite able to apply Wölfflin's classical categories when we analyze abstract painting, while twentieth-century interpretations often strike us as ode-like and pretentious. But here Aristotle's ancient thesis (as stated in the Poetics) — in genuine works of art there are no voids, there is nothing superfluous, nothing can be added nor taken away, nor show any sign of aging. This does not mean that all of Kandinsky's abstractions, especially the early ones, are examples of perfection. But it does allow us to appraise the best of these works. When, with the *Improvisations* and *Compositions* of the late teens, Kandinsky made his final break with the object world, he preserved (until the early 'thirties) the feeling of dynamic, even organic, life in his paintings.

49. *Composition. Red and Black*, 1920,
Oil on canvas,
96 x 106 cm,
Museum of Fine Arts,
Uzbekistan.

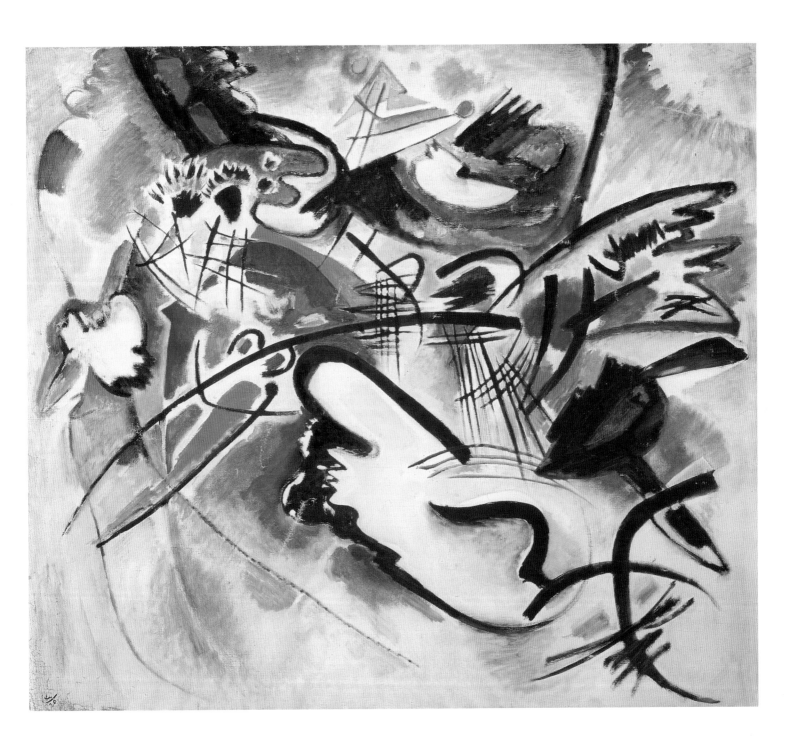

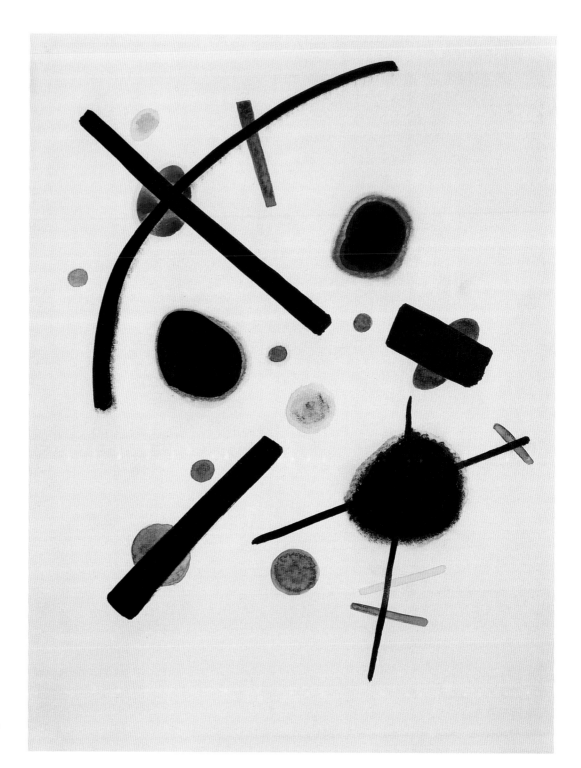

50. *Untitled*, 1920-1921,
 India ink and
 watercolor on paper,
 Tretyakov Gallery,
 Moscow.

51. *On Yellow*, 1920,
 Oil on canvas,
 Museum of Fine Arts,
 Uzbekistan.

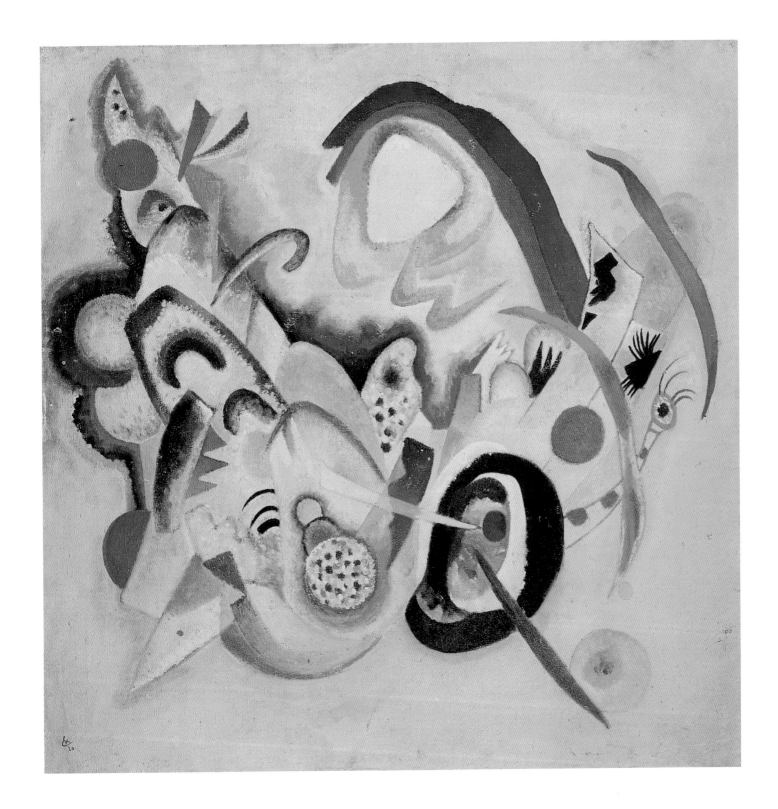

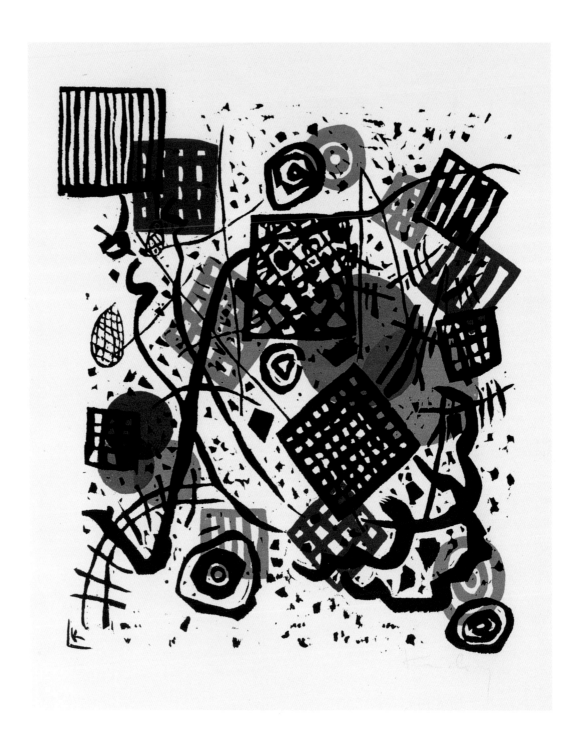

52. *Small Worlds V*, 1922,
 Color lithograph,
 36 x 28 cm,
 Städtische Galerie im
 Lenbachhaus, Munich.

53. *Blue Circle*, 1922,
 Oil on canvas,
 110 x 100 cm,
 The Salomon
 R. Guggenheim
 Museum, New York.

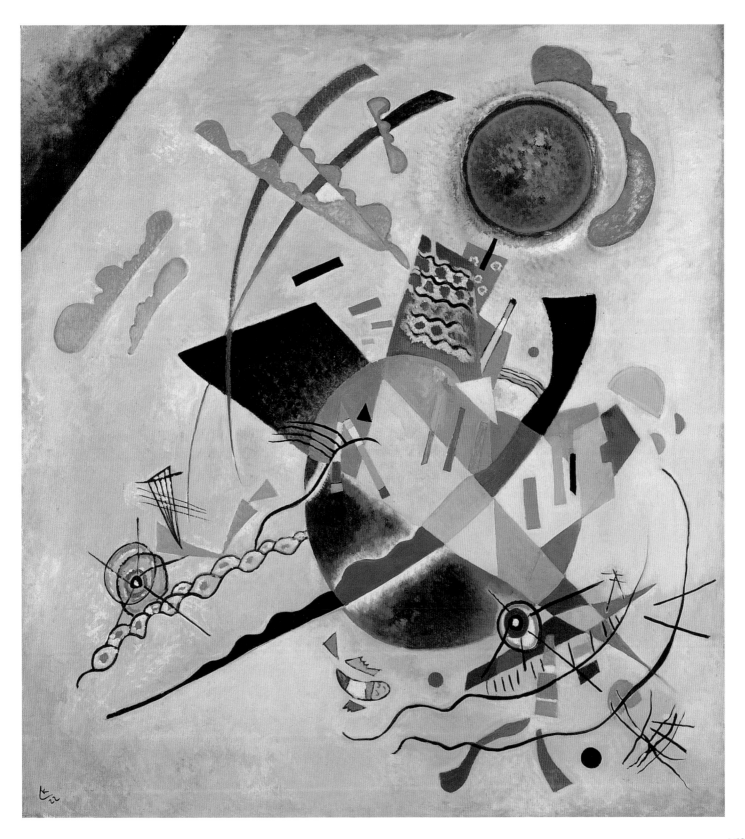

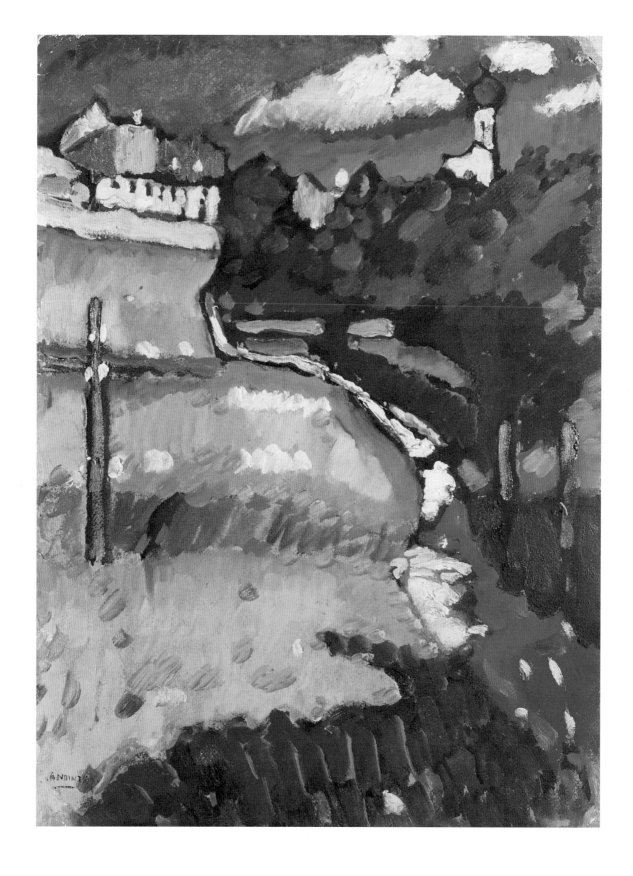

Would we be justified in calling these works "non-figurative"? This "something" is not seen from without, but it does exist in consciousness and, therefore, is not subject to the usual system of coordinates. In consciousness, what is seen now and what was seen long ago, the imaginary and the known, what has been retained in memory and what is hazily recalled, the apparent and the real, all exist on equal terms, outside of time, without the sense of near or far. But they are unfailingly in motion, in the process of becoming. They are in proximity not simply to cosmism (Kandinsky's cosmism has already become almost a commonplace in art criticism), but also to that contemporary philosophical and fantasy literature in which such wholly scientific concepts as "quasar" and "black hole" have become dramatic metaphors.

In Kandinsky's paintings, even the black anguished clots of darkness become festive and joyous explosions. The paintings cannot manage without these explosions, which purify consciousness; eschatological visions become emotional harbingers of change. Take the famous canvas *Black Spot* (1912, Russian Museum) (p.27): the doleful exultation of a golden space exploded by a dark and, at the same time, blinding flash, a flash that destroys any sense of peace, but likewise lends a dramatic equilibrium to the picture's formal structure. Anxiety brings harmony to anxiety itself: this is akin to the psychoanalytical studies of the period, but is not this natural? In this picture one can detect without a doubt the dominance of the paintwork principle over the linear, although spatiality vanishes to the extent that the artist is gazing into the depths of consciousness.

Instead of the usual coordinates of depth, height and width, something similar to what Hesse called "the surplus dimension" appears. Formally speaking, the painting might serve as a canon of plastic and colorist equilibrium; but there is no peace in this world; the "freeze-frame" does not provide for immobility. As long as our eyes are focused on the picture, we believe in equilibrium: it is as if the process of contemplation maintains an unstable calm.

Once the viewer turns away, the fever of consciousness destroys a mad world which had halted for a moment. These works of Kandinsky are capable of relieving the troubled human soul of the burden of unconscious anxiety, an anxiety that no one is able to comprehend because it is devoid of those qualities that can be verbalized. Kandinsky's anxious visions, as if portraying and subtly estheticizing the phantoms of our unrealized passions, render them capable of explaining the inexplicable, of relieving man of the terror of loneliness and incomprehension: there is meaning, rhythm and harmony even in a frightening world. It was hardly within the power of traditional art to "erase the accidental traits," for they are nothing other than those details of existence which give figurative art its life.

54. *Church in Murnau*, 1908-1909, Oil and tempera on cardboard, Museum of Fine Arts, Omsk.

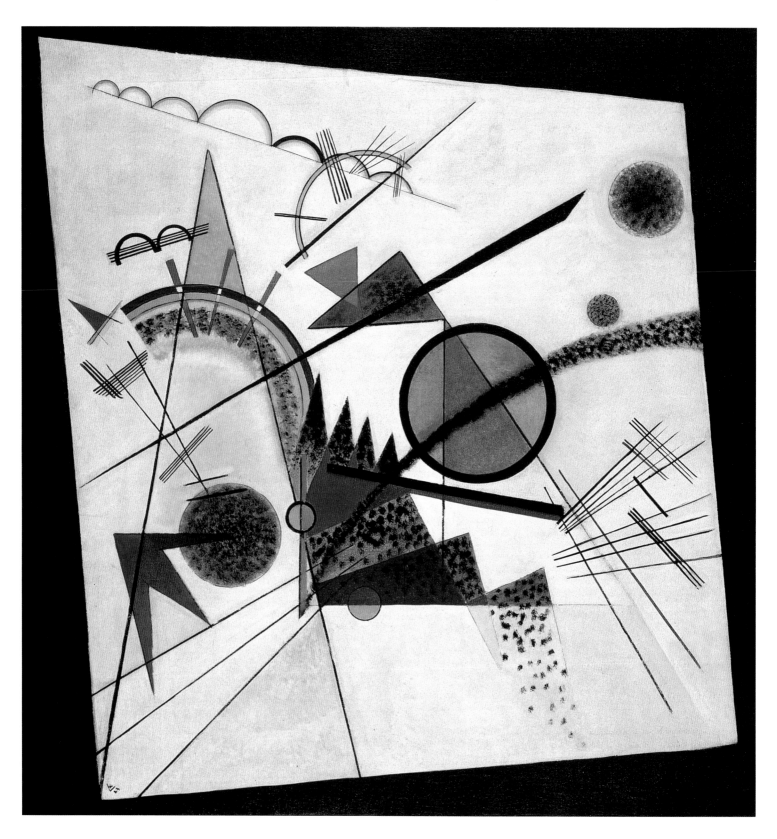

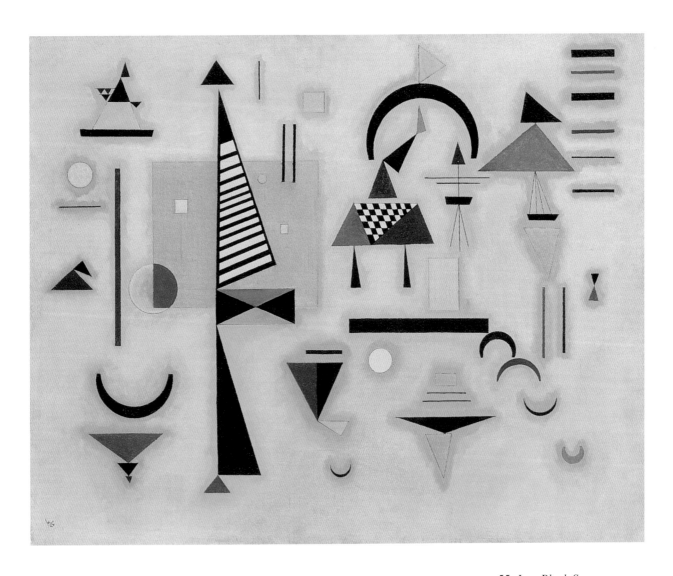

55. *In a Black Square*,
 1923, Oil on canvas,
 97.5 x 98 cm,
 The Salomon R.
 Guggenheim Museum,
 New York.

56. *Decisive Pink*,
 1932, Oil on canvas,
 80.9 x 100 cm, The
 Salomon R. Guggenheim
 Museum, New York.

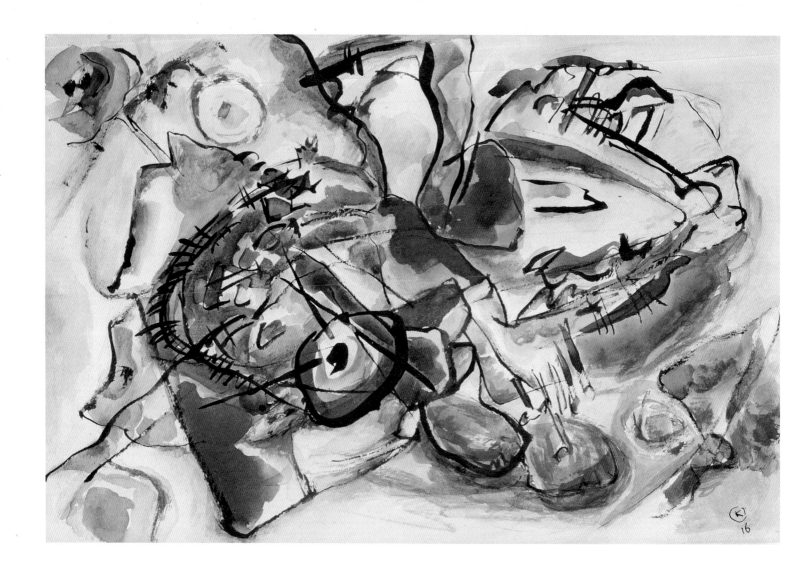

57. *Composition*. Watercolor,
 Tretyakov Gallery,
 Moscow.

58. *Several Circles*, 1926,
 Oil on canvas,
 140.3 x 140.7 cm,
 The Salomon R.
 Guggenheim Museum,
 New York.

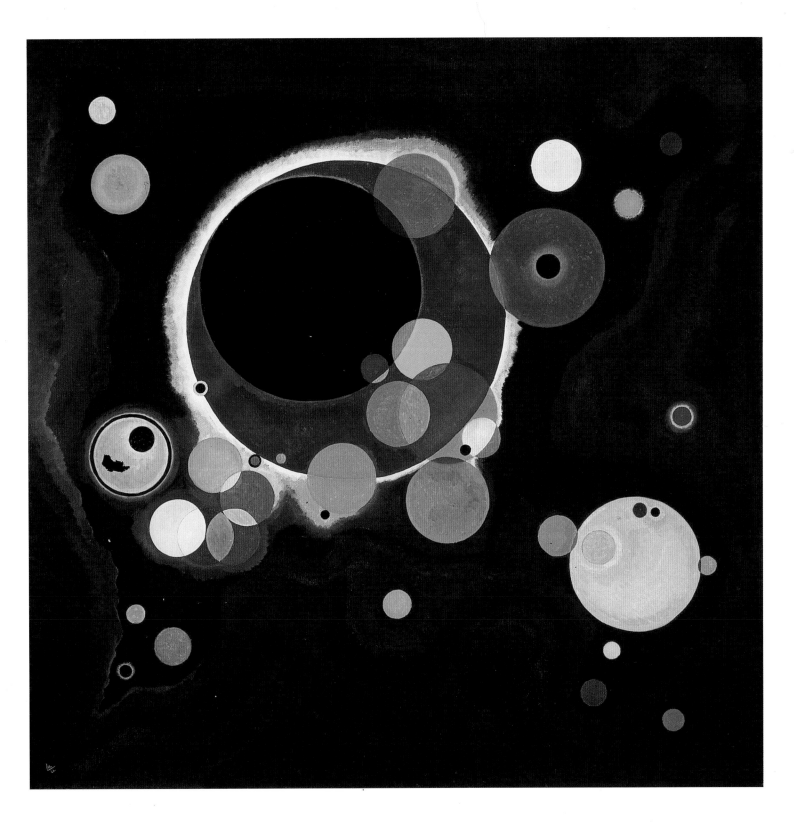

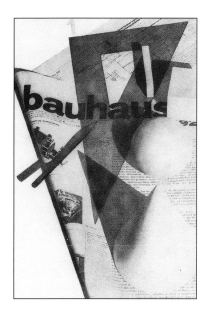

59. *Title page of the Bauhaus magazine,* 1928, Museum of Modern Art, Centre Georges-Pompidou, Paris.

60. *Floors,* 1929, Oil on cardboard, 56.6 x 40.6 cm, The Salomon R. Guggenheim Museum, New York.

Kandinsky's paintings appeal directly to the depths of our spirits, bypassing those "gates of reason" that allow us to perceive any subject-based work of art. On his canvasses arise worlds which science-fiction writers will still be a long time in conquering. It is striking how naturally and profoundly his art harmonized with the image structure and problems of twentieth-century culture. The artist's authority was not based only on his best works and his artistic practice.

The precise conclusiveness of his theoretical judgements, swathed in the halo of his own vague and haughty poetic interpretations, provoked a fascinated attention. It would be unforgivably naive to place all of Kandinsky's written works, including his poems, in the same rank as his paintings. Not bothering to examine the nature of the political changes that were taking place in Russia at that time, Kandinsky quite willingly accepted a number of official posts in the newly-formed government organizations. He served as director of the Museum for Pictorial Culture and for a time he headed the monumental art section at INKHUK (Institute of Artistic Culture).

His works were acquired by the state. Like many other liberal-thinking members of the intelligentsia, he assumed that after deliverance from the moribund czarist regime, things would change for the better. But nothing changed for the better and, leaving for Germany in December, 1921, he would never again return to Russia. Six years earlier he had come to a Russia where a new and mighty avant-garde movement had arisen. He left the Russian Soviet Federal Socialist Republic, where freedom in art was living out its final years. In the summer of 1922, Kandinsky began teaching at the Weimar Bauhaus. Recalling this period, he writes that he felt indebted to his students.

This corroborates what we have already said about Kandinsky's having become a master from the very beginning through the instruction of others. It is likely that for Kandinsky this was a time of complete self-realization, the feeling of being in the right place at the right time. Professional stability combined with the chance to teach gave him confidence that his theory was being heard by those he was making masters. At the Bauhaus he succeeded not only in pursuing the theory of monumental art, but in realizing his own massive designs with the help of his students: a situation reminiscent of Renaissance guild brotherhoods and one that naturally gave Kandinsky the particular sense of a total and profound interaction with the universe.

It was then, in the first Bauhaus years, that he began work on his Worlds, works in which he quite directly contrasted the grandeur of the great and the small. The Worlds were qualified as "Small," and in this lay both their meaning and a paradox: by definition a world is something great, it is essentially everything. And this everything is small? "Yes," the artist answers.

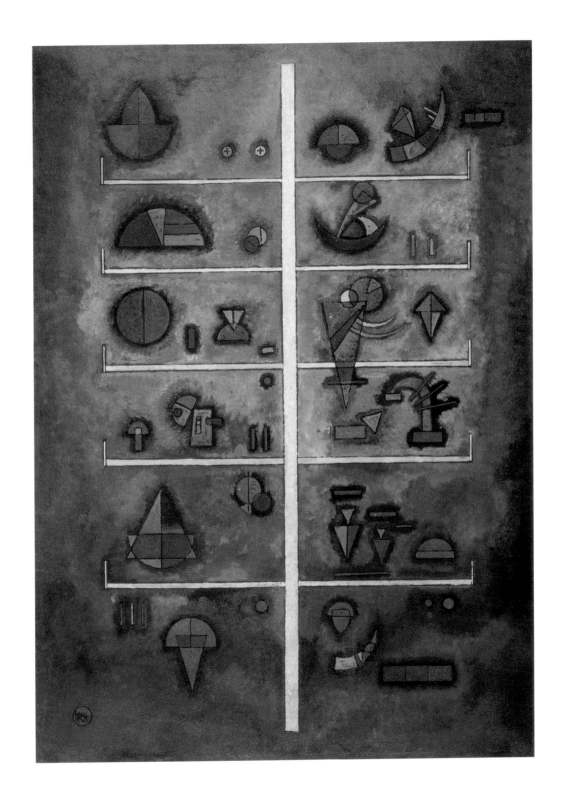

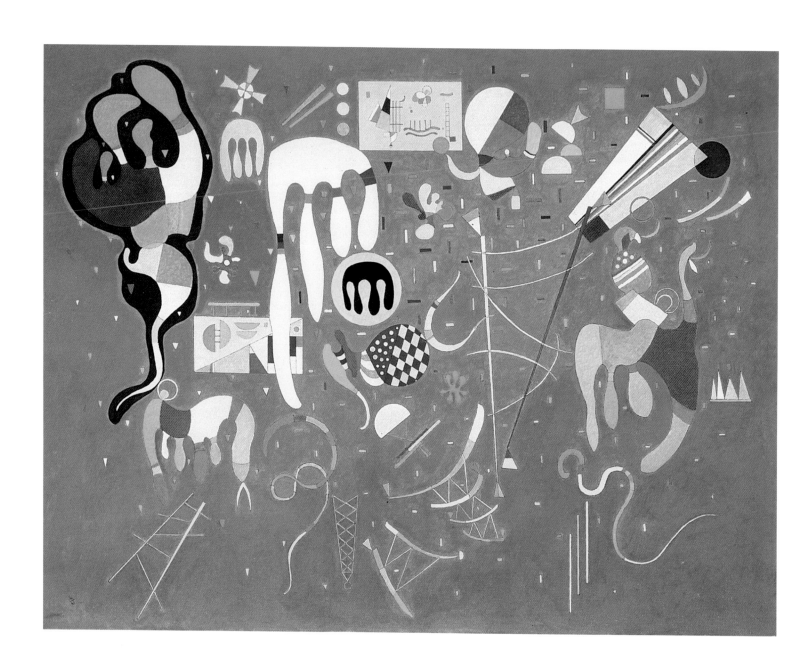

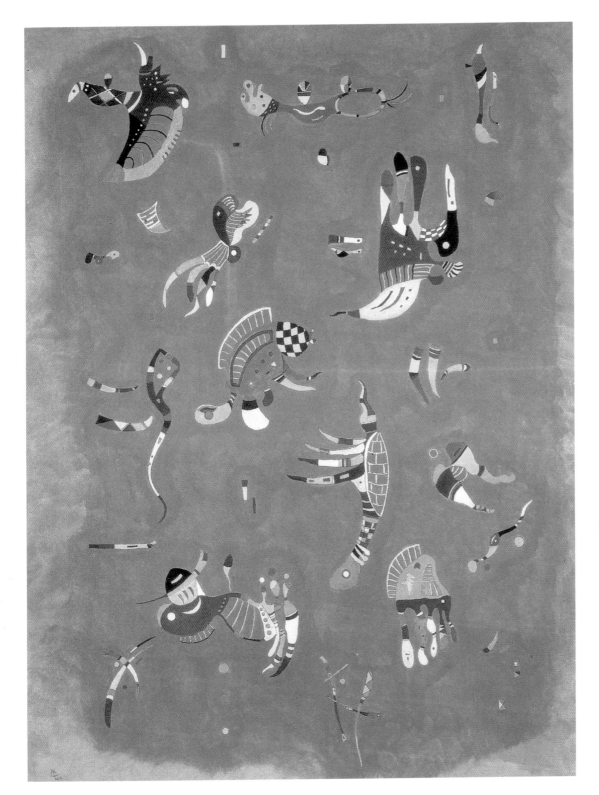

61. *Varied Actions*, 1941,
Oil on canvas,
89.2 x 116.1 cm,
The Salomon
R. Guggenheim
Museum, New York.

62. *Blue Heaven*, 1940,
Oil on canvas,
100 x 73 cm, Museum
of Modern Art, Centre
Georges-Pompidou,
Paris.

It is as if, "it can be concentrated in an atom, in an atom's particles, for the consciousness of man is neither great nor small, and only in it do worlds have their existence." The grandeur of the small (and the smallness of the great) is sharply felt in his graphic masterpiece *Small Worlds V* (1922, Städtische Galerie im Lenbachhaus, Munich) (p.62). Pragmatically and merrily assembling fragments of past art and art near at hand, the post-modernists have scarcely risen to the regal heights of *Small Worlds*, in which a noble refinement of technique brings an entire era of experiments to fruition (within a surprising and individual stylistic unity).

In keeping with the *Small Worlds* are the studies for the mural painting of the Jury frieze exhibition in Berlin (1922 Centre Georges-Pompidou, Paris). To some degree, these passionate but precisely calculated compositions are a tribute to various tendencies within Kandinsky's own art, and to tendencies in modern art in general. Here we find a crystallization of the planetary and zoomorphic myth so typical of Kandinsky (panel A), almost geometrical compositions (panel C), and something reminiscent of Miró's experiments (panel D). "...All roads which we traveled separately until today have become one road, which we travel together, whether we like or not," wrote Kandinsky in an exhibition catalogue.

In these years Kandinsky's fame grew with that of the Bauhaus. Europe's artistic elite came to its exhibitions in Weimar and, later, in Dessau (to which the Bauhaus moved in 1925). Einstein, Chagall, Duchamp, Mondrian, Ozenfant and Stakovsky were among the guests of Kandinsky and the Bauhaus masters. Kandinsky exhibited regularly and with success. His sixtieth birthday (1926) was marked with a massive retrospective exhibition in Braunschweig. In 1929 Solomon Guggenheim bought one of his paintings.

Kandinsky noted (1929) that non-figurative painting "continues to develop further towards a cold manner" and that for surrealism (then in its developing stages), abstract form might seem "cold."

The artist himself determined the essence of what was happening to him in the context of his environment. On the one hand, the presence of surrealistic overtones in his art is unquestionable. Those splendid carnivals of the subconscious, those "landscapes of the soul," realized in his simultaneously menacing and festive paintings from the 'teens, had already been a partial contact with the poetics of Surrealism. With the passing of time, on the other hand, images consonant with the experiments of the Surrealists (who find the going tough in the chilly surroundings of Kandinsky's intellectual abstractions) are to be glimpsed fleetingly in his works. *Several Circles* (1926, Guggenheim Museum) (p.69) is an almost square canvas with a staggering feeling of universality, of that unity of the infinite and the small to which Kandinsky had so aspired.

63. *Different Parts*, 1940,
Oil on canvas,
89.2 x 116.6 cm,
Gabriele Münter and
Johannes Eichner-
Stiftung, Munich.

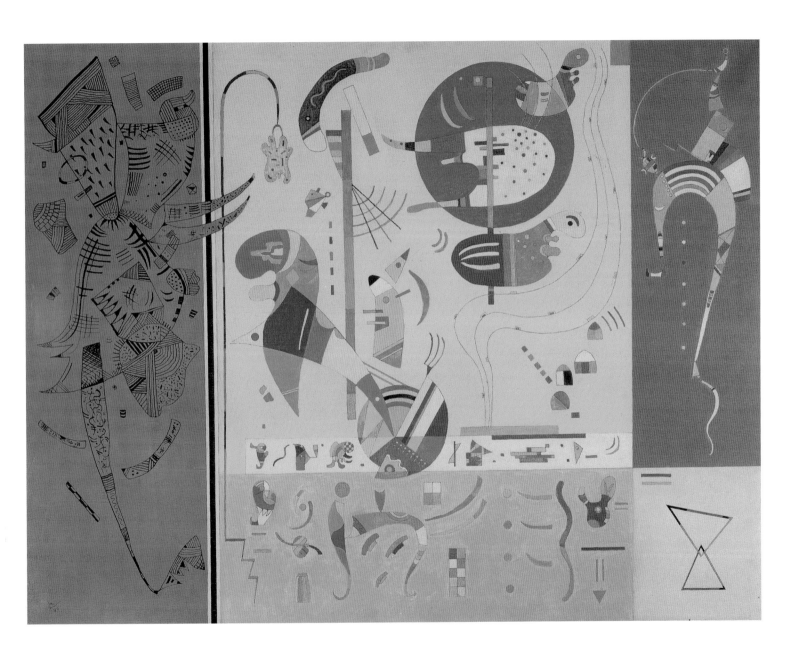

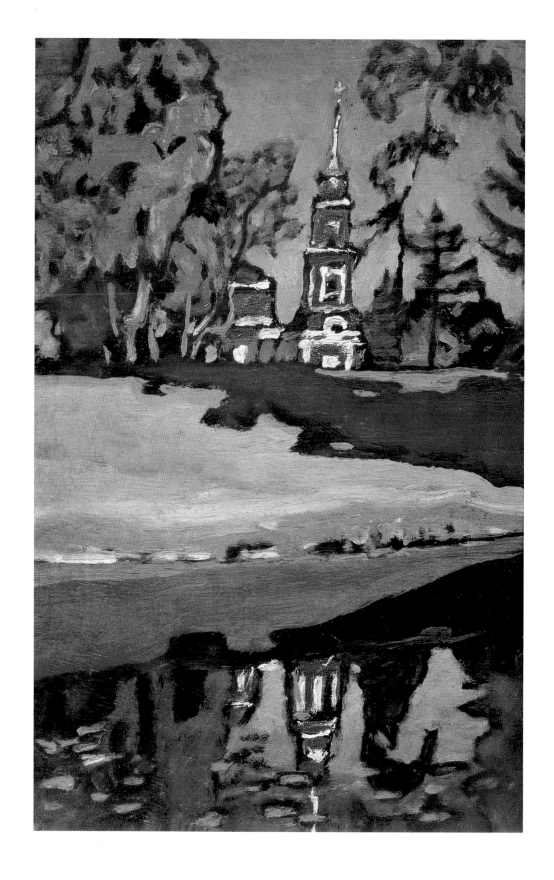

64. *Red Church*, 1901,
Russian Museum,
St. Petersburg.

Kandinsky courageously equates "the home of illusion" with reality; he even makes the imagined world more stable, haughtily gazing down on the vanity of the real world. As if all the earlier *Small Worlds* and the passionate explosions of the early abstract works and had abated, concealing in their cold depths the secret energy of dark suns. A tense and bleak calm, an equilibrium triggered to fatally (though not yet imminently) explode — all of this is submerged in a timeframe not at all commensurable with the brevity of human life — a time that has seemingly frozen forever.

Here, it seems, is everything that Kandinsky, that generous wise man, wanted to say to his own age and to the future. As is well known, the artist lived out the last years of his life in France, having left Germany when the Nazis came to power. In Russia he had come to know himself as an artist: Russian motifs and sensations nourished his brush for a long time. In Germany he had become a professional and a great master — a transnational master. In France, where he was already welcomed as a world celebrity, he completed — brilliantly and a bit dryly — what he had begun in Russia and Germany.

Having left his two beloved countries when the darkness of totalitarianism threatened them, Kandinsky ended his days in France, which already long before had become a symbol of freedom in the arts and a place where they breathed most freely of all. Perhaps it is true that, at the end of his career's trajectory, Kandinsky partly lost his originality, but it would be more accurate to say that it was not so much that he came to resemble other masters, as much as other artists were drawn into the "gravitational field" of his art.

This process, however, was a reciprocal one: Kandinsky both took much from his own time and gave much back to it. However much has been written or said about Kandinsky, however many times the weary consciousness of our century has attempted to make his name and art a commonplace in the history of modern culture, Kandinsky's worlds, large and small, have not become easy to understand.

These worlds enchant; sometimes they nonplus; but, as before, they conceal a multitude of strange enigmas. Take the famous painting *Thirteen Squares* (1930, Centre Georges-Pompidou, Paris). Variegated squares — now viscous, opaque and heavy, now tenderly translucent, now shedding their own radiance — swim slowly in a foggy mirage like unburdensome, but serious, thoughts. They form their own small (or gigantic?) world, just as every man — a molecule of the universe — is also an entire universe. They swim, gladdening and troubling us, asking riddles and helping to guess the meaning of life.

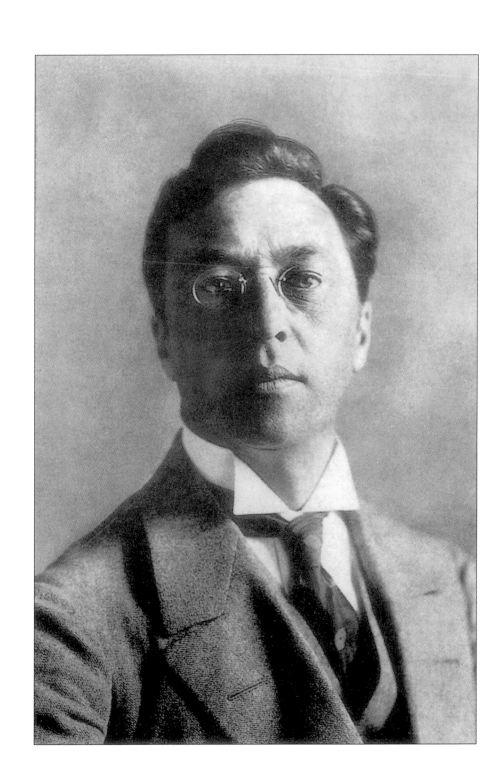

65. *Portrait of Kandinsky*, c. 1913, Photography published in his book *In Struggle for Art (Rückblicke)* in 1913.

BIOGRAPHY

1866: Birth of Vasiliy Kandinsky in Moscow. Until 1885 he attends a gymnasium in Odessa, where he studies drawing and music. He then enrolls in the Law and Economics departments of the University of Moscow.

1889: During a field trip to Volodga he is impressed by the region's expressive folk art.

1892: He marries his cousin, Ania Chimiakin.

1896: After his encounter with Impressionism he moves to Munich, where he studies with Anton Azbè and Franz von Stuck. He meets Alexei Jawlensky.

1901: Kandinsky and his colleagues found the "Phalanx" artists' group, a drawing school, that organizes several exhibitions on various contemporary artistic mouvements.

1902: He meets Gabriele Münter, who will soon become his companion.

1904: The "Phalanx" disbands. Kandinsky and his wife Anna separate.

1906-07: Kandinsky lives in Sèvres and Paris, where he encounters Fauvism.

1908: Gabriele Münter and Kandinsky move to Murnau, in the vicinity of Munich.

1909: He founds the Neue Künstlervereinigung München (New Artists' Association of Munich). Franz Marc becomes a member of the group and Kandinsky's dearest friend.

1911: Kandinsky's first important written work, *Über das Geistige in der Kunst* (*Concerning the Spiritual in Art*) is published.

1912: Formation of the Blaue Reiter (Blue Rider) group among its members August Macke, Alexei Jawlensky and Franz Marc, and publication of Blaue Reiter Almanach (Blue Rider Almanac). Kandinsky's first one-man exhibition takes place in Der Sturm gallery, in Berlin.

1914: The First World War breaks out; Kandinsky returns to Russia.

1915-16: Kandinsky and Münter separate in Stockholm.

1917: He marries Nina Andreevskaya. After the October Revolution Kandinsky holds a number of different positions in newly created Soviet cultural institutions. He is among the founders of INKHUK (Institute of Artistic Culture).

1921: Kandinsky leaves the Soviet Union and returns to Germany. He accepts an invitation from Walter Gropius to work at the recently opened "Bauhaus" school in Weimar. Kandinsky heads up the mural painting studio. He elaborates the analysis of colors and forms he had begun earlier.

1925: The "Bauhaus" moves to Dessau.

1926: Kandinsky's second book is published under the title *Punkt und Linie zu Fläche* (*Point and Line to Plane*).

1928: His production of Mussorgsky's *Pictures at an Exhibition* is performed at the Friedrich Theater in Dessau.

1933: Under Nazi impact, the "Bauhaus" is closed, and Kandinsky emigrates to France. Still exhibiting, he lives isolated from the Parisian scene.

1937: During the course of the "Degenerate Art" campaign in 1937, many of his works are confiscated from German museums or destroyed.

1944: Kandinsky's last exhibition at Galerie l'Esquisse in Paris. He falls ill and dies in December at the age of 78.

LIST OF ILLUSTRATIONS